ANH DUONG
(SELF)PORTRAITS

© 2001 Assouline Publishing, Inc.
601 West 26th Street
18th floor
New York, NY 10001
USA
Tel: 212-989-6810 Fax: 212-647-0005

www.assouline.com

Texts on pages 48 and 98
translated from the French by David Wharry.

ISBN: 2 84323 285 6

Color separation: Gravor (Switzerland)
Printed in Italy

All rights reserved.
No part of this publication may be reproduced,
stored in a retrieval system, or transmitted in any
form or by any means, electronic, mechanical,
photocopying, recording, or otherwise,
without prior consent from the publisher.

ANH DUONG
(SELF)PORTRAITS

ASSOULINE

INTRODUCTION

by Glenn O'Brien

Paint Time Is In Today portraits are photographs. No one has a painting on their driver's license or passport. Sometimes you need a painting, but usually only if you are the president or chief executive officer of a school or corporation that is older than photography. Otherwise a Kodak moment will usually do.

Portrait painting is a lost art, lost deliberately, when painting found bigger fish to fry. But portraiture is now so dead it has to be revived, so lost that it must be rediscovered. The laws of fashion demand it. Portraiture is dead! Long live portraiture!

If you're looking for the future in the fashion world you can pretty much go straight to the bottom of the barrel, the thrift shop barrel, where the clothes that are most out can be found for the lowest prices. "It's so out it's in" is a functioning principle because what's way out of fashion appeals to the youth who would oppose or overthrow the fashionable viewpoint, and it's also appealing because it is the cheapest possible source of clothing. That's how fashion starts, with the kids on the street who catch the designer's eye. Outness is infra-in.

It's the same principle at work in art, where the residual forces of modernism require something that resembles progress. In art, many crucial parts of the immediate future can be found in what's most "out." Portraiture, still life, landscapes— some of the most traditional practices in art—can be seen as a radical departure today, having been sufficiently aged at the bottom of the barrel. Portraiture and self-portraiture were made endangered species by modernism. Conceptualists intent on destroying painting, went straight for the head.

But now, perhaps, the heads are rolling back in. The stacks of lumber, bales of hay, explosive devices, chewed up lipsticks, live wires, deconstructed texts and dangerous furniture have been moved into the warehouse, and human faces, oil on canvas, are being nailed to the white walls. Everything old is new again, and as they used to say on the island kingdom of Dr. Moreau, "Are we not men?" Sometimes painting is dead. But sometimes painting is back. And all at the same time. In the paintings of Anh Duong, painting never left. This method has never been discontinued in practice, only in favor. This self-portrait has always been painted. But at this time it's becoming timely. Timelessness is becoming very timely. It could save us from progress, if we can just catch the driftless spirit of it. When the gimmicks just aren't moving anymore it's time to pull out the classics and market a renaissance.

That's just the tip of why portraiture could be crucial this time around. In an era where eugenics and cosmetic medicine plan to rock your world at a considerable profit, it is good that we will have reminders of what the human face was. And in a world where the concept of personality has become a container filled with ephemeral, disposable trends, it is good that we will have some records that noble, immutable, last ditch personality existed at the flash point of millenial shift.

In the world of paint, time passes very slowly. Oil oozes too quietly for the human eye. Day brightens and day darkens subtly. In the world of electrons, time flicks on and off and on every second and the eye reels in the strobe's inhuman rhythm. Between these extremes flesh breathes in and breathes out, blood courses at its usual speed.

Professional Face Anh Duong was a professional face. She was a model who was in a lot of great clothes in a lot of important photographs and runway shows. As a model she wore clothes and walked. Sometimes she posed for pictures. Modeling is usually thought of as a passive occupation, and often it is. Very little participation may be called for. But the models who are most in demand are often very good at having their picture taken. They have learned what they look like and they know how to look that way.

Some see narcissism in Anh Duong's paintings, an easy charge to level at an artist whose principle concern is self-portrait, but narcissism is properly understood as morbid self-love or self-absorption and Duong certainly does little in her paintings to glamorize, beautify or mythologize herself. Her portraits are not flattering. They detail her imperfections. What beauty there is seems more of a function of serenity or acceptance than enhancement.

The story of Narcissus is the story of someone who mistakes his image for another person and falls in love with that imaginary person. Duong's image, as she renders it, is not a beloved image, it is a contemplated image that is surprisingly neutral in emotional content. Her face is a form repeated and repeated. In fact her

practice seems to be the opposite of narcissism. Her painting tends to erase the emotional content from the face, stripping away what is not essential. The face becomes a playground for the accidents of light and shadow. Here form and content are clearly on the same page.

Public Image, Private Eye "A god is an eternal state of mind. How is a god recognized? By beauty."—Ezra Pound, *Guide to Kulchur*. Being a gossip star is beside the point. Access to image transmission has a point. It is a port of entry into the media mind. Every artist has a model. Every model has an artist or two. The conjunction of these roles strikes a nice balance in a world out of whack in its subjectivity. The self-portrait is the objectification of subjectivity and vice versa. The renaissance human recognizes the objectification of the subjective as a divine thing.

Ugly Beauty That's the title of one of my favorite Thelonious Monk tunes. Some say ugly beauty describes the way Thelonious played the piano. It is that and more. It is also a kind of art movement without borders that describes many works that work in today's overstimulated image environment. Ugly beauty? I wrote: "Beauty alone is a perilous thing. To carry off extreme attraction you need some repulsion built in to send the stalkers fleeing. That's what Jesus meant by turning the other cheek. Be prepared to use your bad side. Two faces are always better than one."

6

Duong's paintings resonate with ugly beauty, like Monk's minor chords playing in and out of scheduled time. She's doing it the hard way. There is no photo here. This is painted from life in a tricky position. Anh Duong's pictures syncopate the long run.

Duong's portraiture, whether it is self-portrait or a commission, is a painstaking process. Self-portraits are often physically difficult because the pose she has assumed makes it difficult to apply paint to the canvas. The physical awkwardness of the pose brings a certain extraordinary effort that gives the line intensity. Sometimes she has to figure out how to squeeze feet into a tight frame. That's the nature of improvisation. This is done in real time, no freeze frame. Hand moves, paint dries.

To get this world right you have to get it a little wrong. As Leonard Cohen says, "There's a crack in everything; that's how the light gets in."

Again And "Abstract painting needs a frame."—Neil Jenny. Artists make the same painting over and over again. Every painting is a self-portrait. Anh Duong is more conscious of that process than most. These painting own up to their sorority and do so without any disguises. This is naked painting. The subject matter disappears through repetition.

Repetition means reduction. The more functions that are automatic, the greater the abstraction. The mountain, the cathedral, the face—templates for interior abstraction.

Self-? I remember the "me decade." In fact, I remember all the "me decades." They were good training for the "self century" beginning the "moi millenium." Self-referential, self-assured, self-made, self-realized, self-absorbed, self-service, self-serving, self-abusive, self-aware, self-denying, selfless, selfish, self-taught, self-aggrandizing, self-delusional, self-centered, self-winding, self-educated, self-propelled and perpetuating, self-contained, self-denying, self-inflicted, self-defeating, self-helpful. We are all these and so much more.

God is not monitoring the inner dialogue anymore. You're on your own kid. Self is so much a part of what we do now, but it's often just assumed. When the self is acknowledged it changes the tone and the meaning. It is challenging, sinister. Or substitute auto. Auto-erotic, auto-biographical, autonomous, autocratic, automatic.

Recently I encouraged an artist to do some portraits (not on commission). She said, "Why would someone want to buy a portrait of someone else?" She was describing the world that shops. I was unprepared. I could only answer something about pictures of girls hanging over the bars in saloons in western movies. You never know where you'll find an eye for art these days. But when they've taken everything away, self is what's left. If you can see it, then it's style.

Easel Painting VS. Extremist Glamour "How did it come about, you well may ask, that entire generations of painters have gone to school with abstraction, have acquired a peculiarly barren technique, in which there are none of the natural delights of interpretations of nature which have always made painting and drawing and sculpture so delightful a discipline? A very great part is played in the conversion to extremism by vanity and snobism….the extremism in the arts…is a pathological straining after something which boasts of a spectacular 'ahead-ofness'—looking upon the art in question as a race."—Wyndham Lewis, *The Demon of Progress in the Arts*.

A particular charm of Anh Duong's paintings is their success in a realm that is not involved in currency, in avant-gardism, or fashion (as chic as their context may be), but in the pure practice of timeless painting. These pictures are not ahead, they are not behind, they are paintings in the permanence of the relation between paint and the human form. They are out of time, in the moment.

"Forward?" said Arthur Rimbaud, "Why not about-face?" Progress will take you so far. We speak at the speed of light. The joke strikes California before it hits the back of the room. But moon missions end, Concordes are grounded, and finally the human race progresses, like the human face: possibly. These paintings are about a step forward and a step back, journey and return. Their value is in their existence as products of a traditional craft, in a time when that is most rare and unlikely.

CONVERSATIONS WITH MYSELF

By Anh Duong

To paint, to not forget that breath that goes away. Each mark attached to a moment of my life. It is not about reproducing a face, but recording the invisible. An absurd quest, responding to the fear of loss. A feeling of emergency and accident with oil. An erasable mark, leaving a trace where everything is possible. Like a broken heart. Responding to the need to survive.

What terrifies me and to which I am drawn, is that nothing is ever the same. I would never be able to go back, or find your stare again in the same light. It's not about wanting to paint, but to continue this long path, where each painting is never finished, where each love letter is never received. Starting over again, without trying to succeed, continuing without wanting to arrive. Forgetting the requirements of the visual law. To paint, because I can't say it in another way. Without trying to take care of my line. And this incomplete conversation keeps me alive, interrupted by moments of extreme pleasure, like moments of grace. Where one can be moved to tears, by the illusion that a red creates when meeting an ochre. A mix of incompletion and inspiration.

Who has never been preoccupied by the resemblance, but the effect produced by the stroke. If one line could say everything, I would like to stop here. I don't want to describe, but make appear. And what will not be said will speak the most.

It is in the repetition that I kept the innocence. Staring stripped bare in the mirror

to forget myself. I don't trust my imagination, I am too afraid she will try to remember. She would be telling me what I already know, and would bore me. Painting that face over and over, crossing the distance between what it is in my dreams. And what will it be during the day. Knowing it by heart, I have nothing to expect. Looking beyond the familiar, I would not be tempted to describe it, to hold on to what it reminds me of. The subject and his story don't matter anymore, only forms and colors are left. And I would go straight to the essential. Before it was nothing, now the adventure begins.

You have to love your model or learn to love him. The subject is nothing in himself, what matters is all that could be said about life through him. I don't choose my model, he comes to me. Provoking my desire by the color of a sweater, the blond of his hair, the reflection of the lens of the glasses on his face. I want him to look in my eyes, be disturbed by his presence, in his mute dialogue, where with the hours going, we forget who is observing who. And I will drown where our stare becomes a way to hold the other one at a distance, or the permission of total abandon. Like crossing a hallway separating two rooms. Allowing me to follow every wrinkle on his face, every stain on his skin. Each mark becoming a key of the map, that would lead me to destination. It takes trust to believe that a wrinkle will create the volume of a cheek. Yet, it is by following blindly this wrinkle that everything becomes possible. That one can be deeply moved by the bridge of a nose dying with the birth of a forehead. It is the beginning of a love story where nothing will be consumed.

(SELF)

PORTRAITS

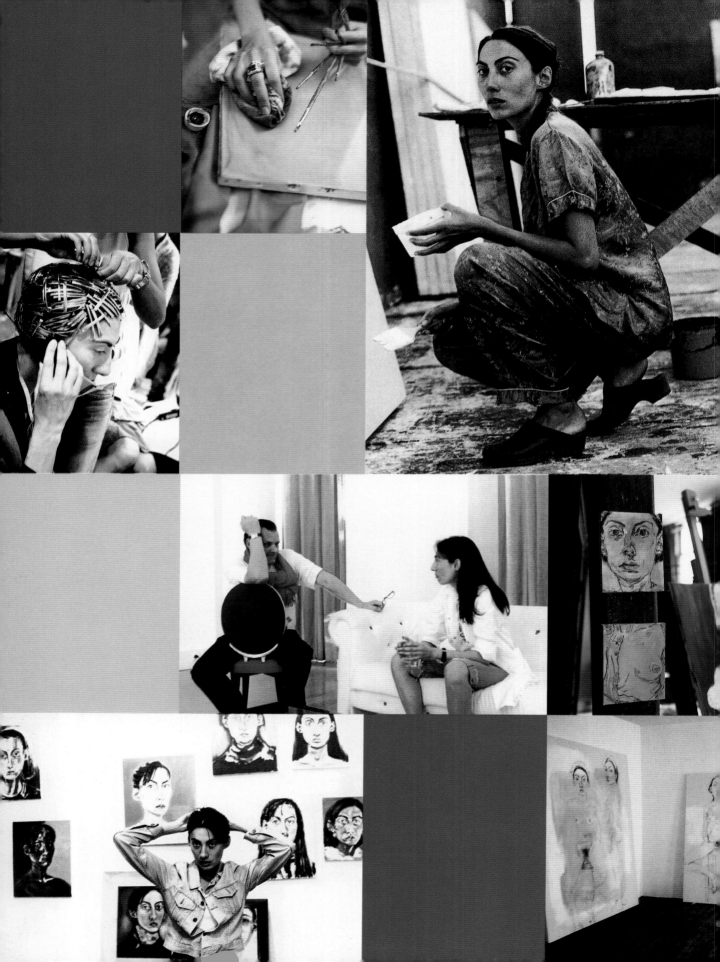

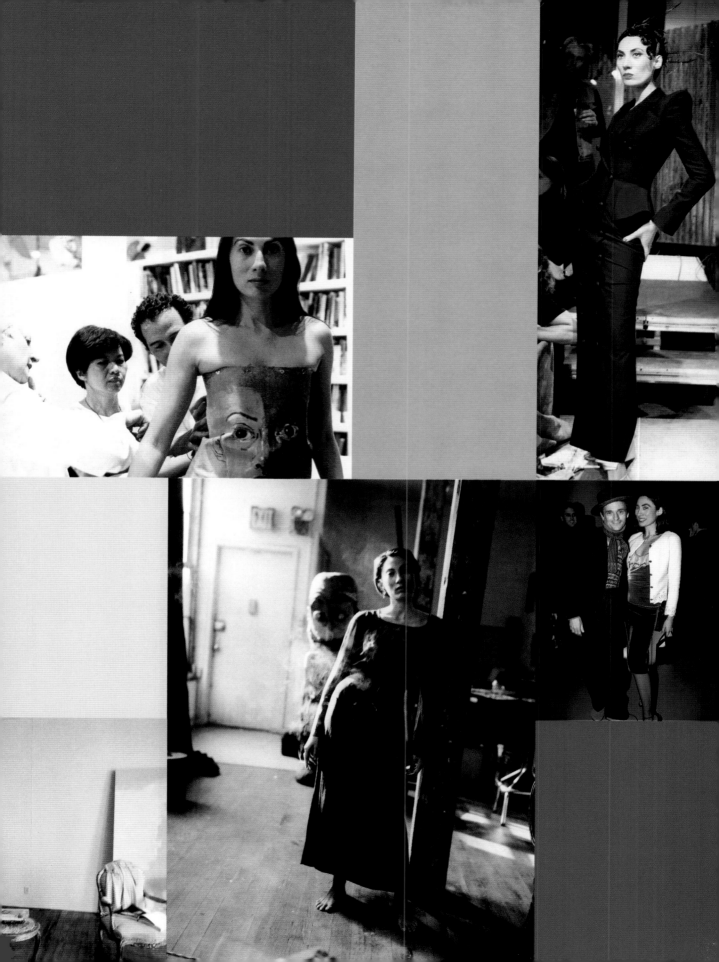

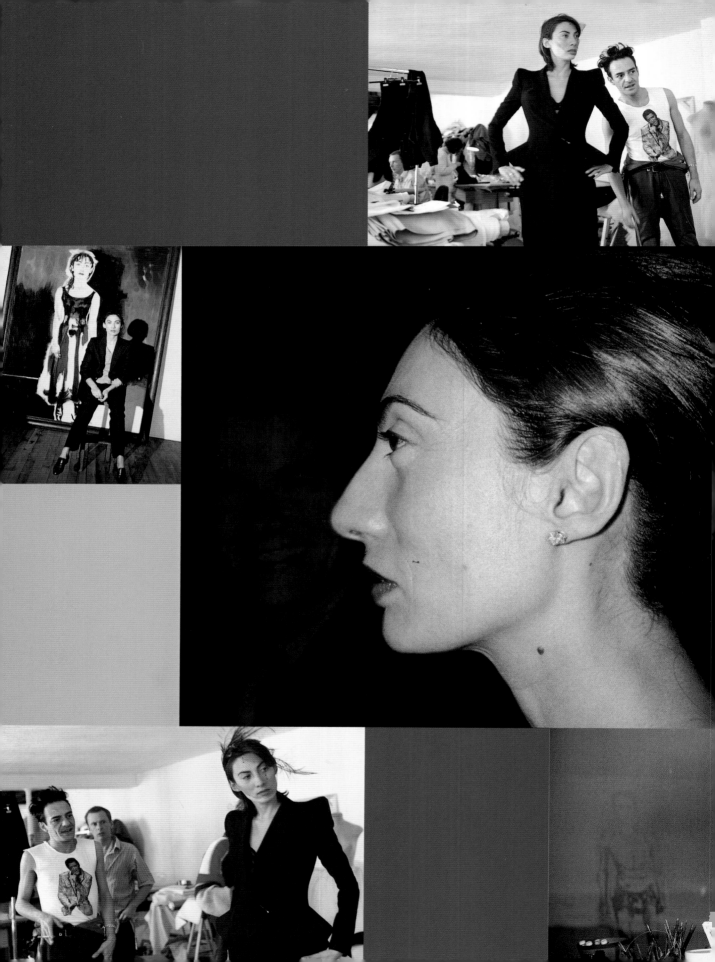

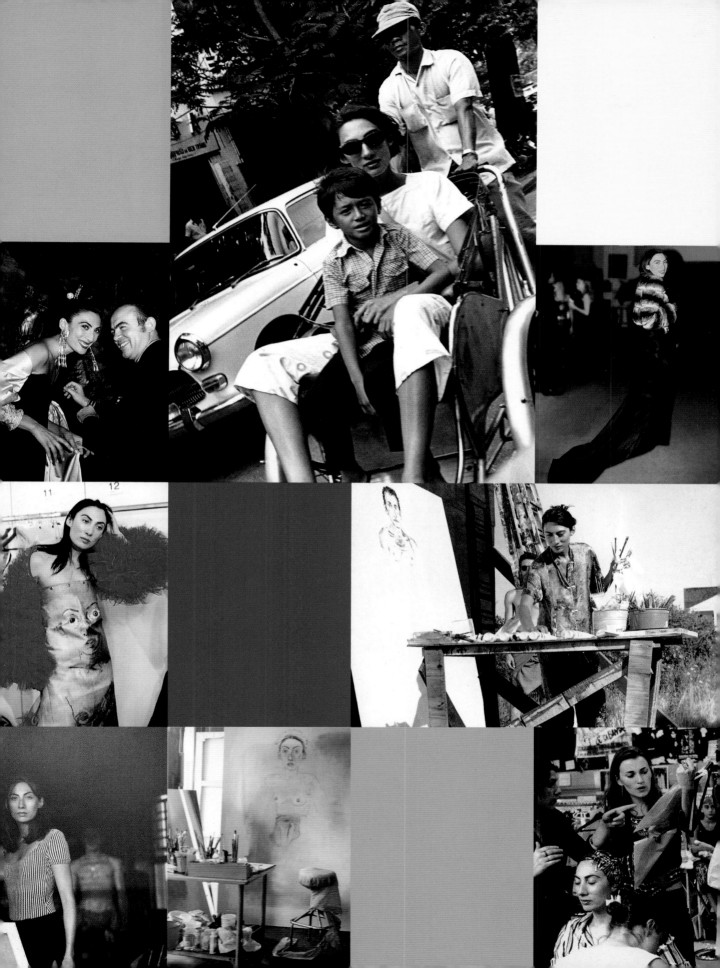

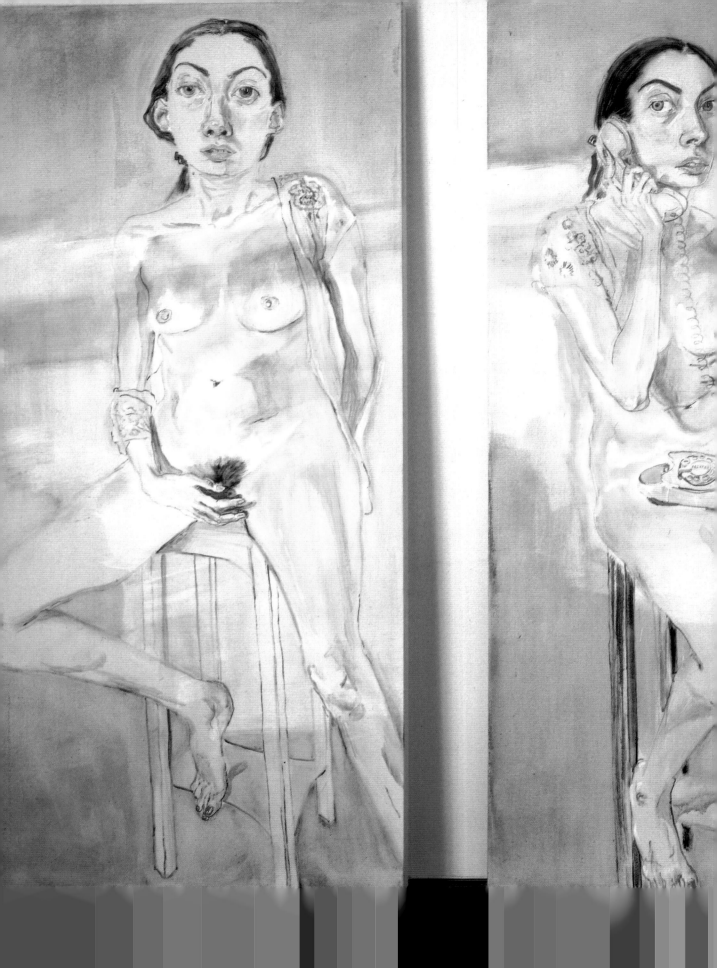

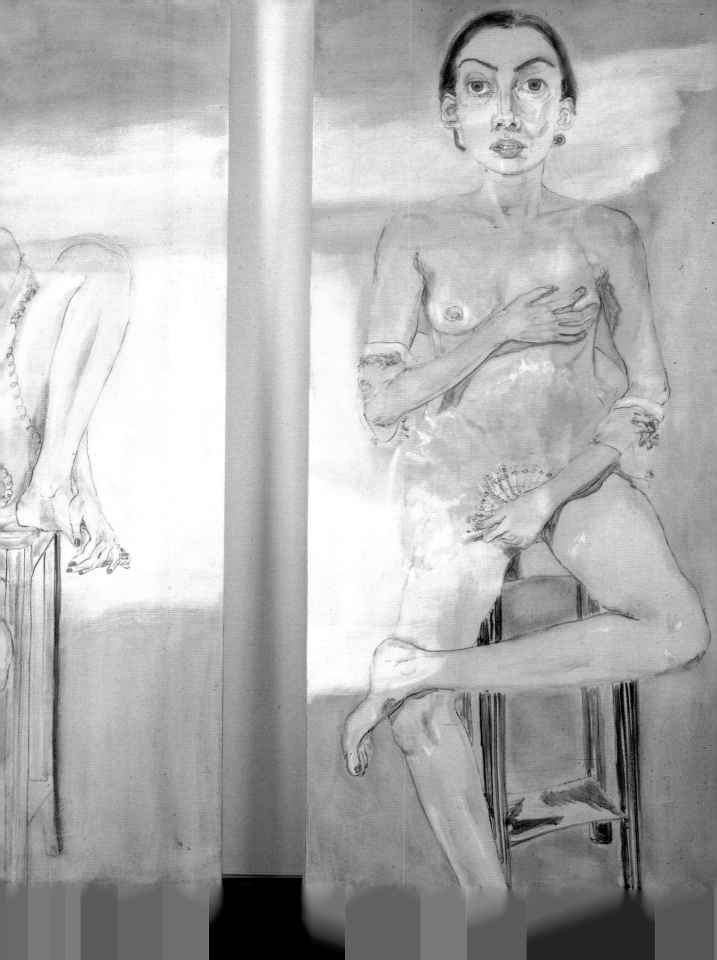

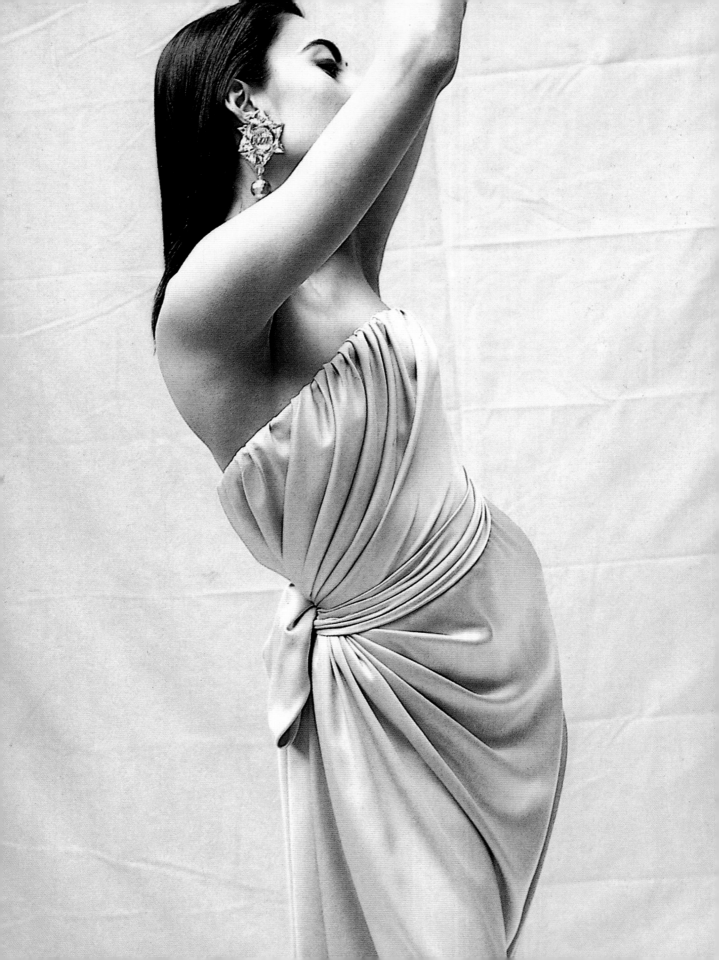

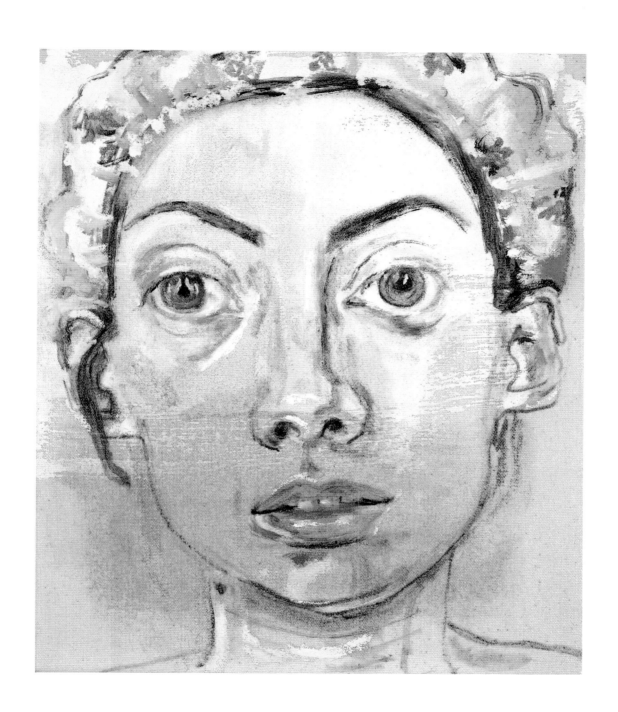

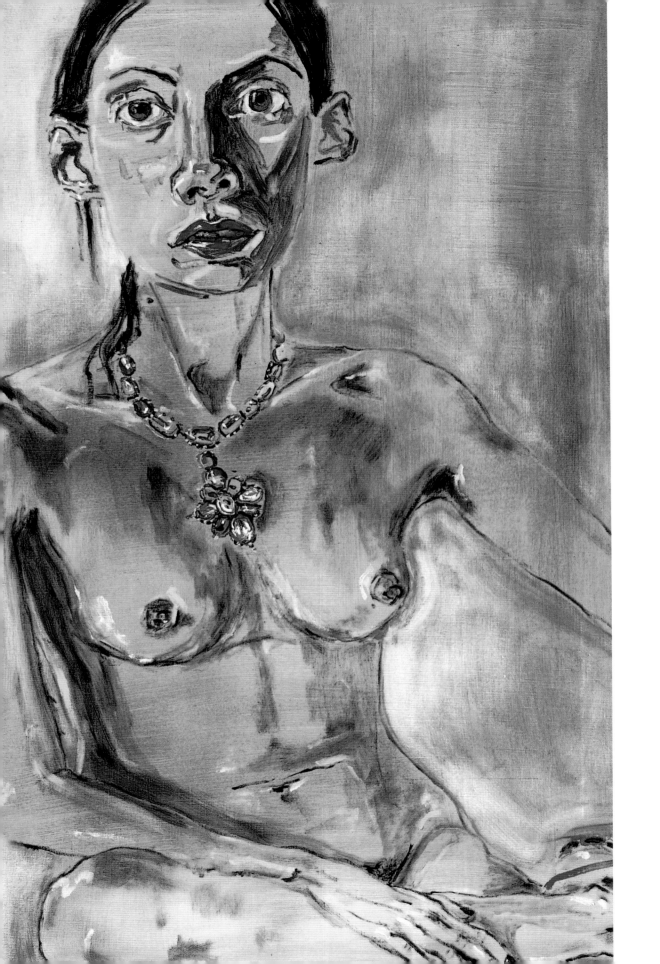

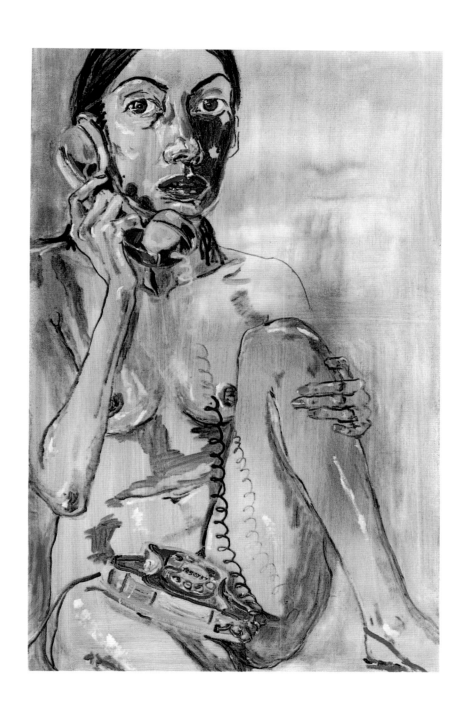

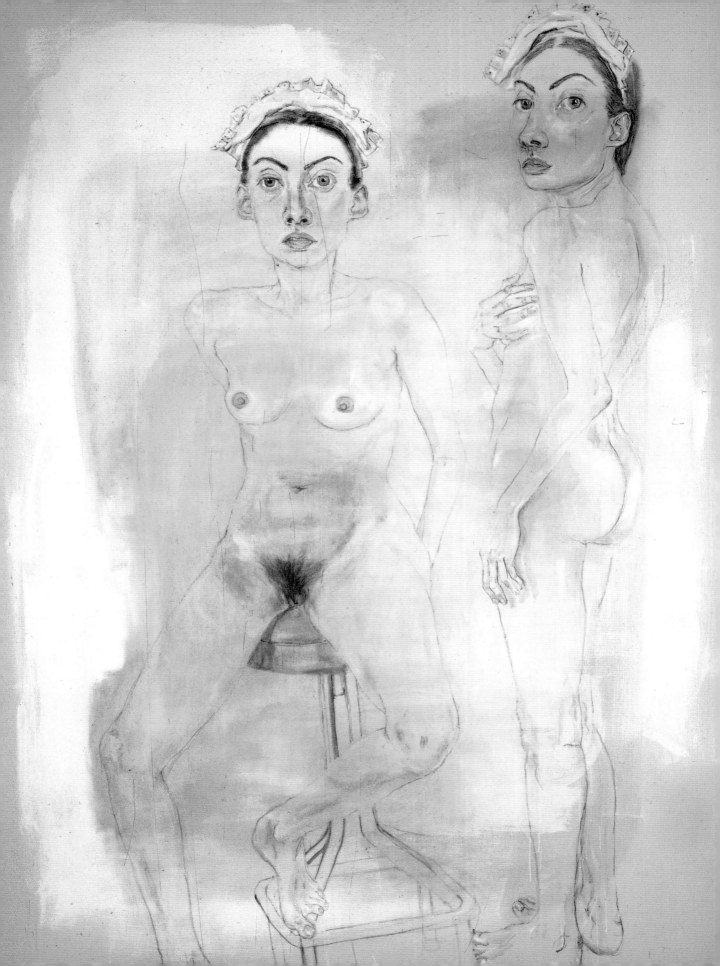

Peter Thomas MacGough

I remember that summer Anh started to paint out on Long Island. Small canvas of friends and some self-portraits very casually but beautifully done. She quickly got better and faster. With each painting comes a more sophisticated technique and line. Anh can make an incredibly beautiful portrait in a few hours. Something I'm quite jealous of. I also like how she uses color. An acid green for a wrinkle around an eye or a pale blue above a lip to shadow. There's a smoothness and clarity to her portraits. Simple and bold. They are sort of like those ancient statues of fertility goddesses—beautiful and scary at the same time.

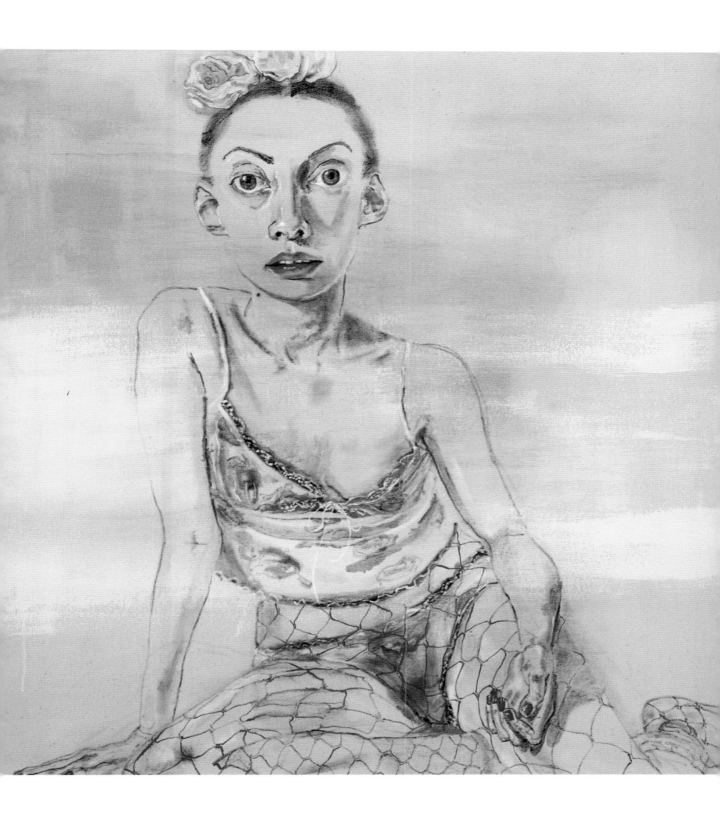

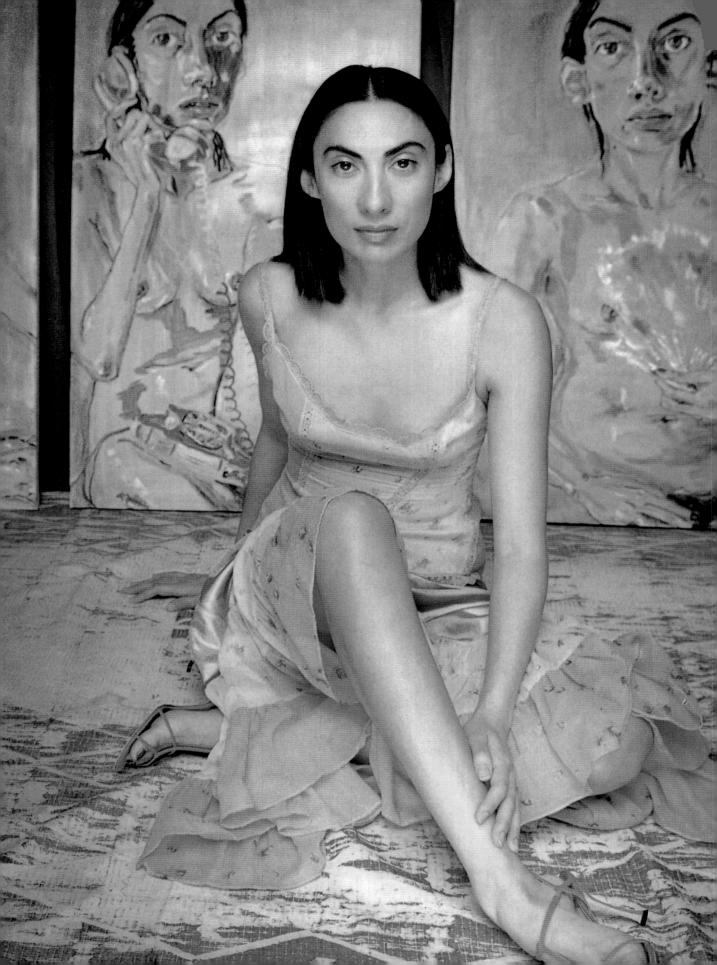

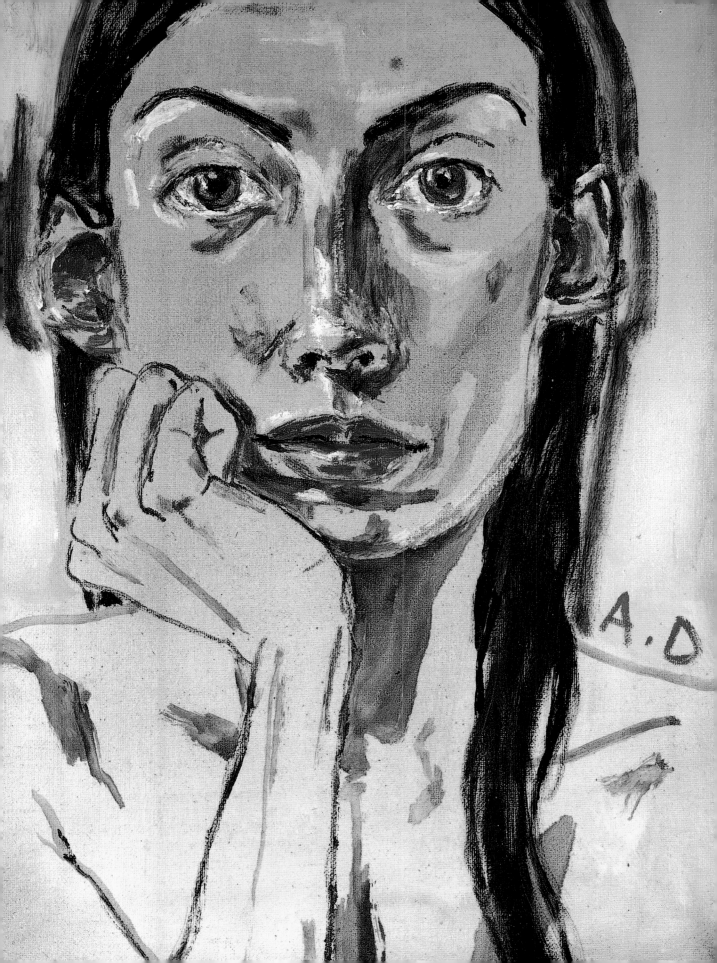

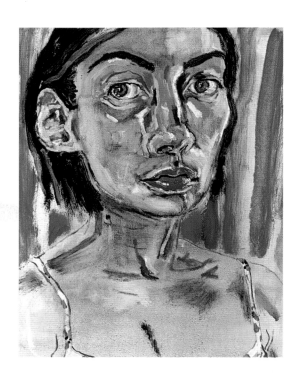

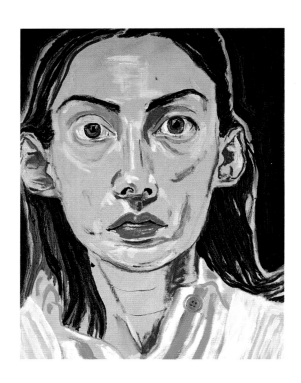

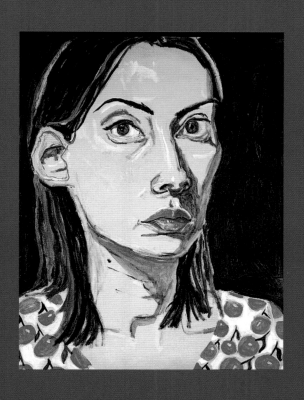
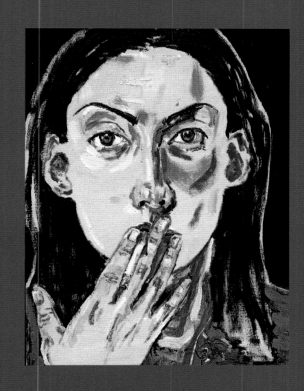

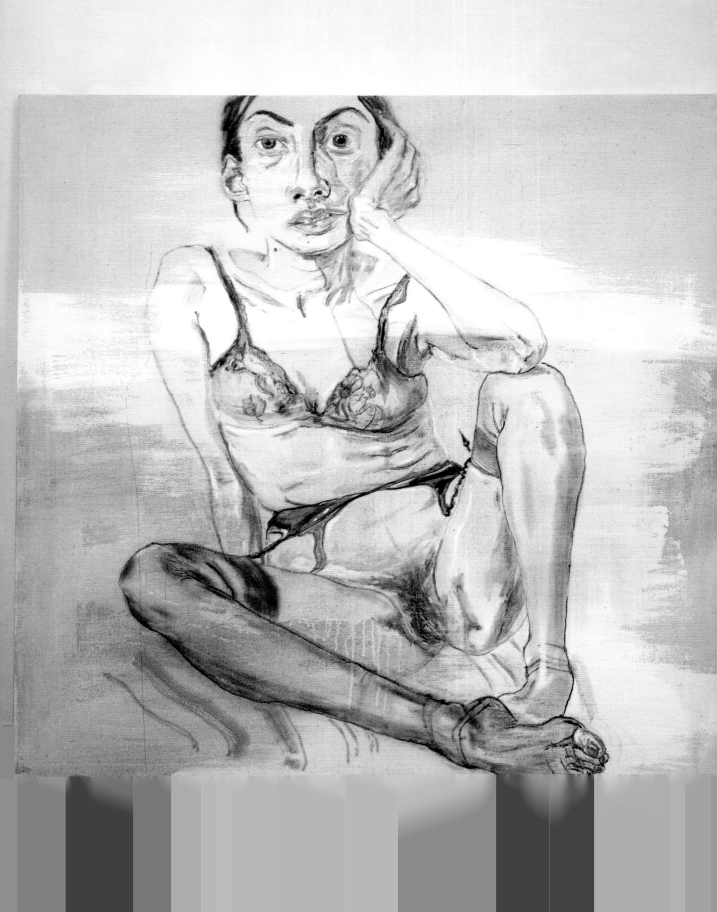

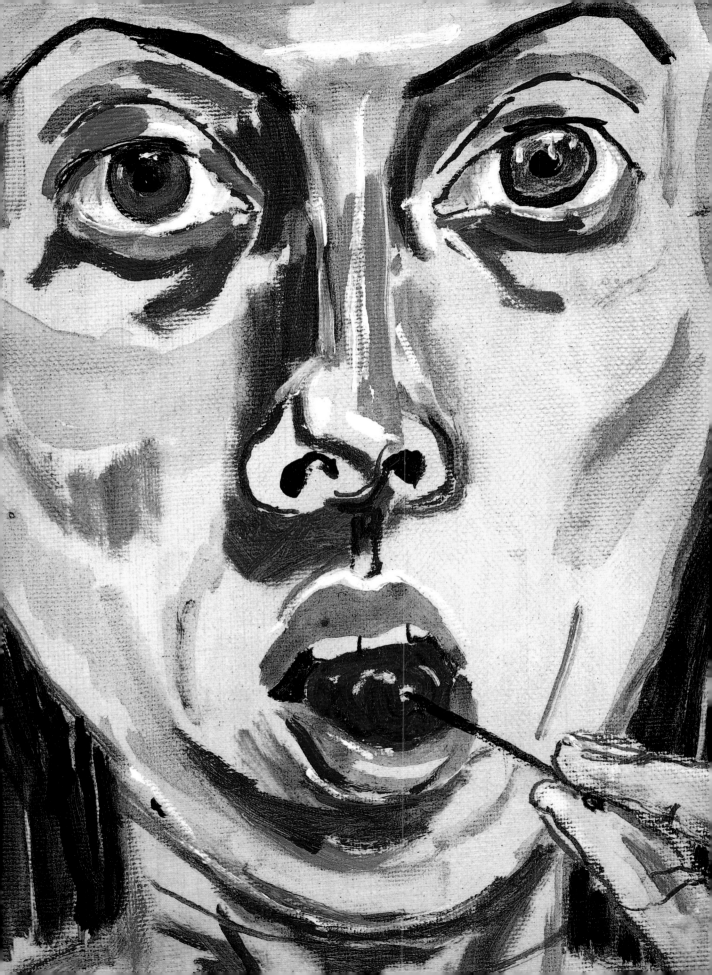

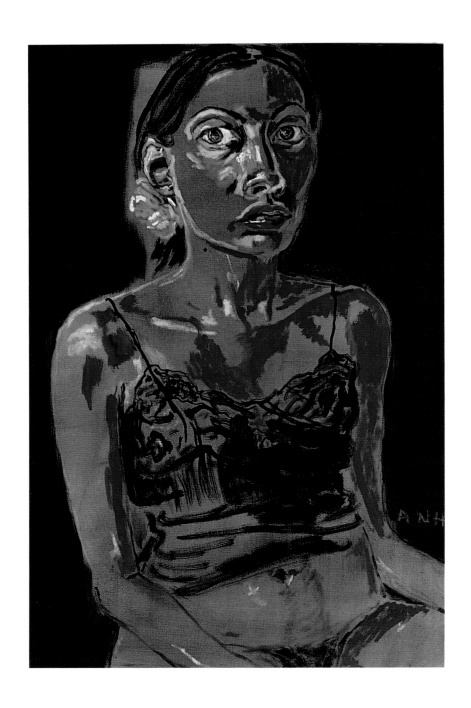

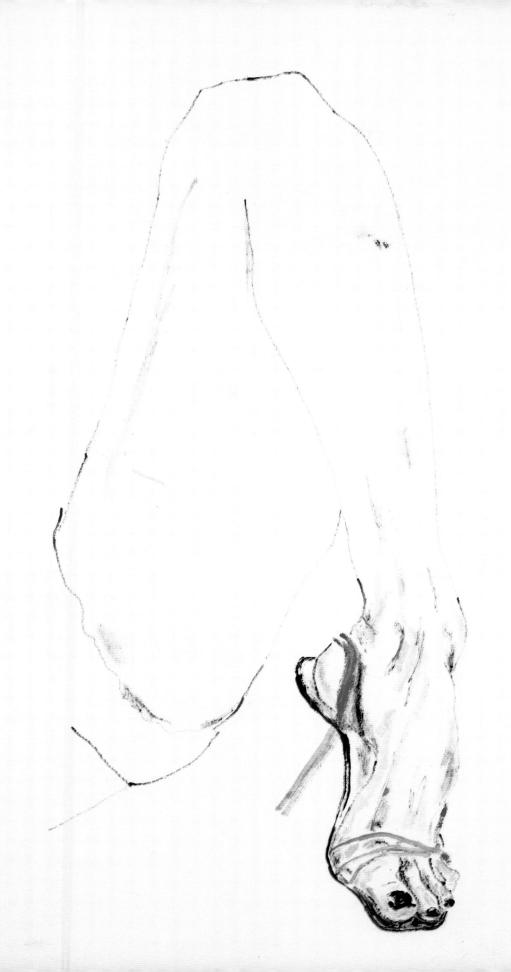

Bob Colacello

Anh Duong is the Frida Kahlo of the 21st century—
unafraid of men, unafraid of sex, unafraid of criticism,
unafraid of being herself. Her work is both brave and beautiful,
stylish and upsetting, way out and too in.
But it is of such contradictions that art is made.

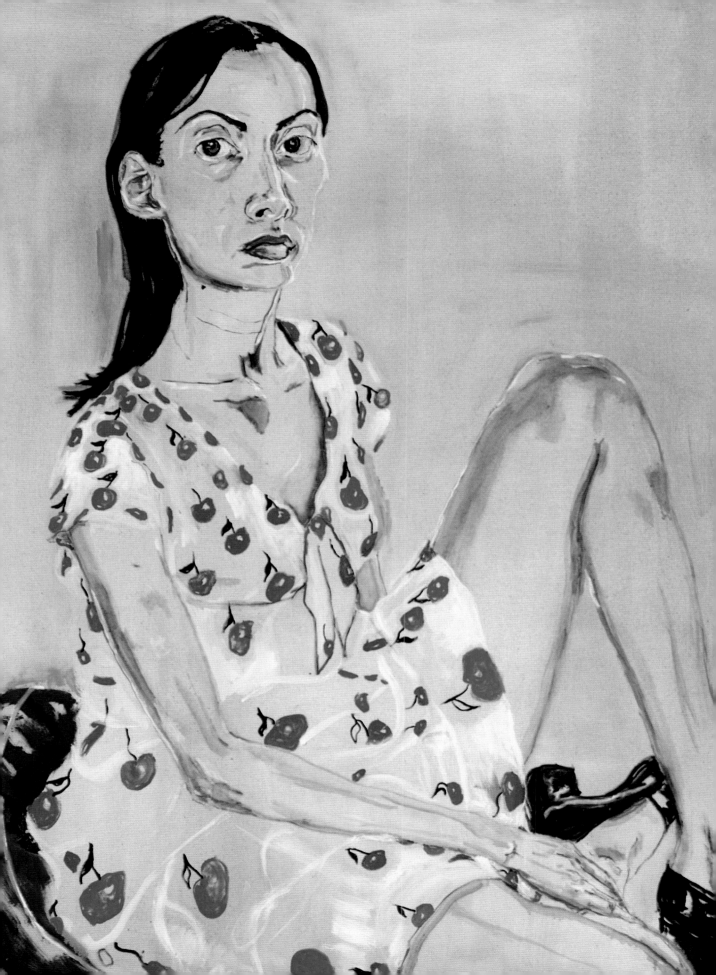

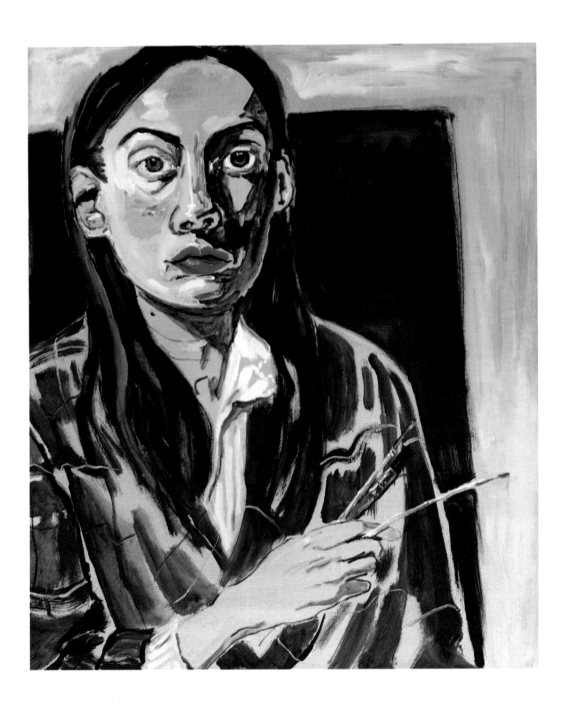

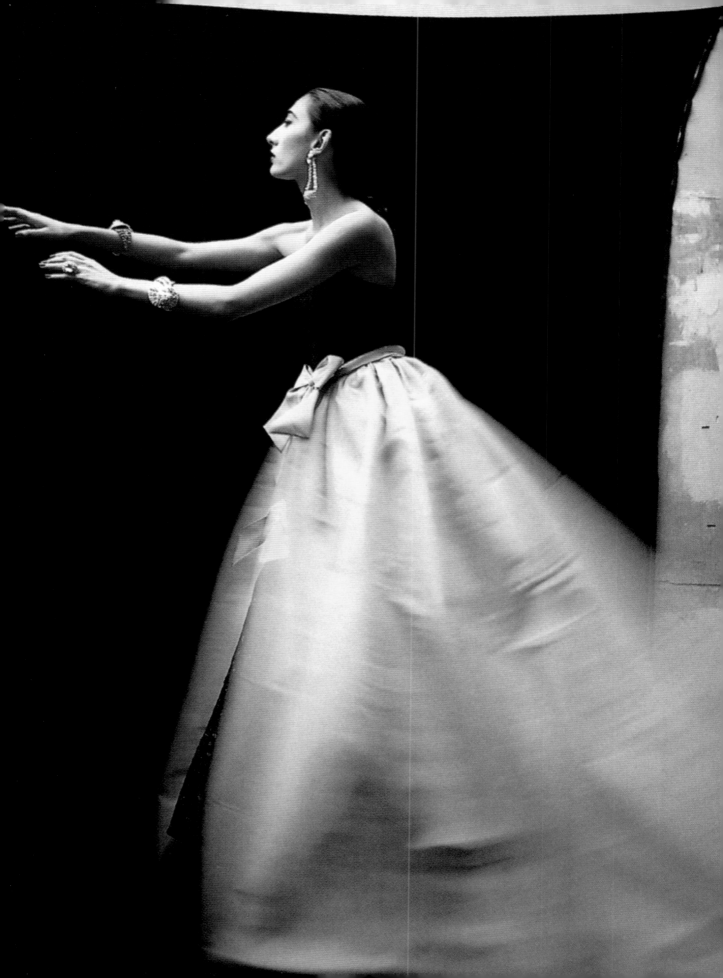

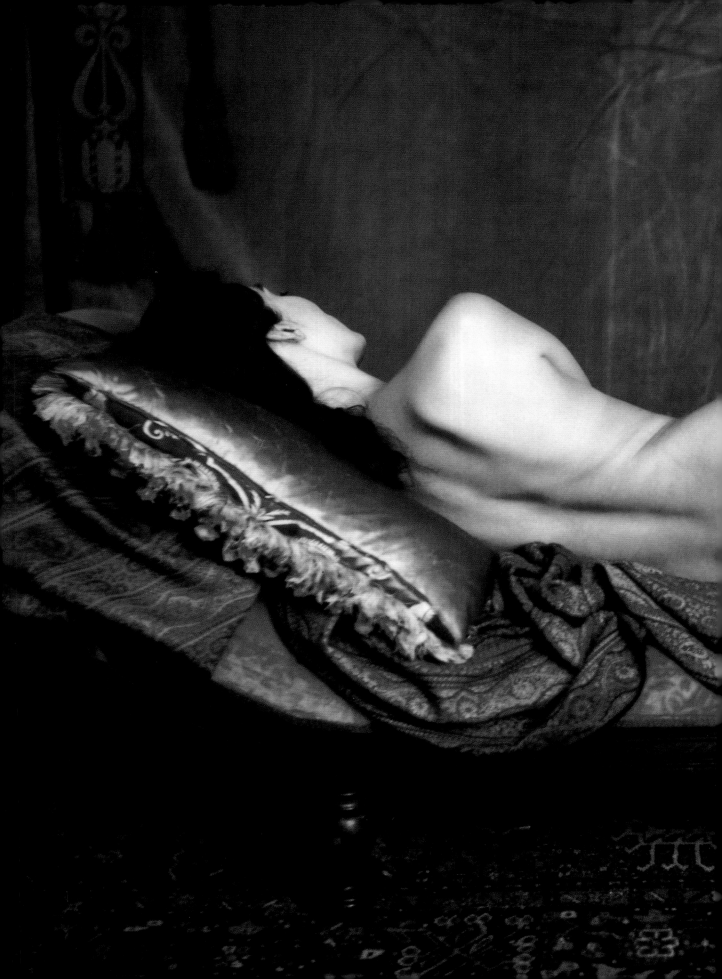

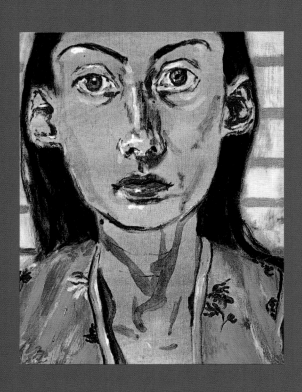

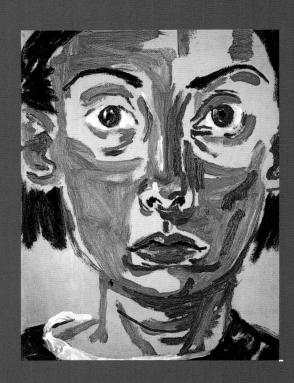

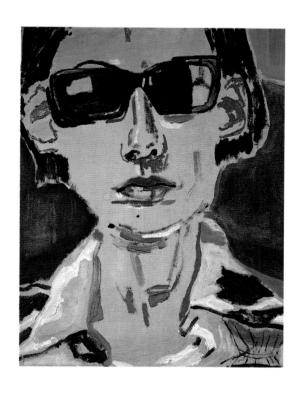 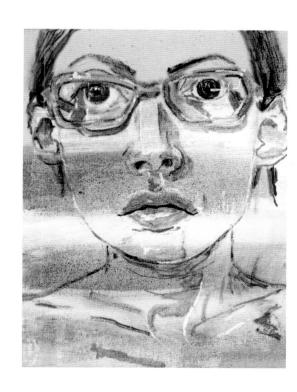

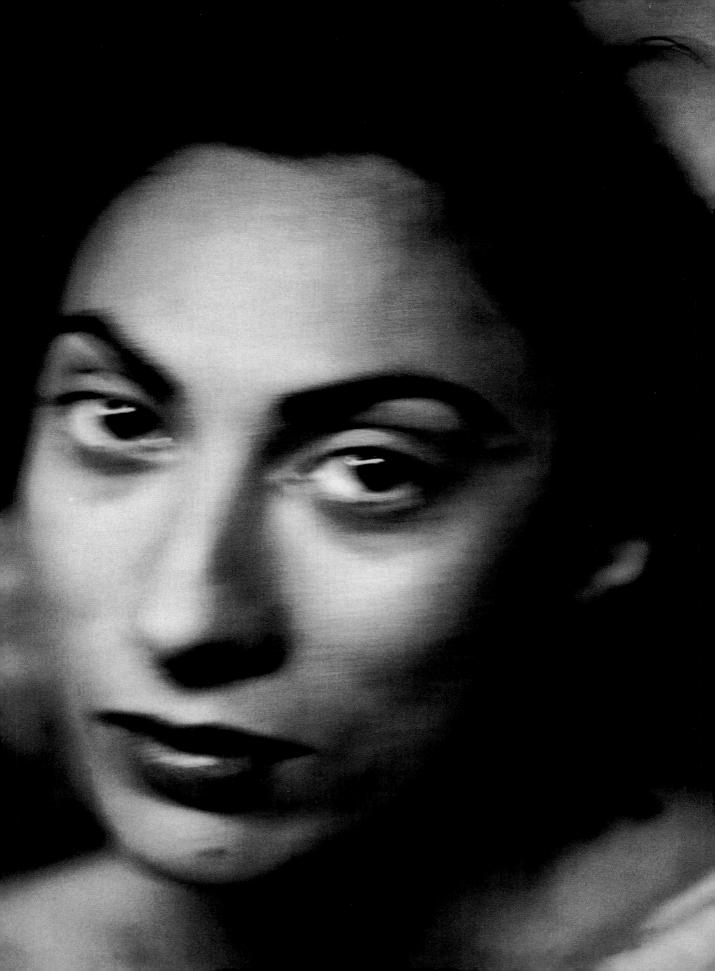

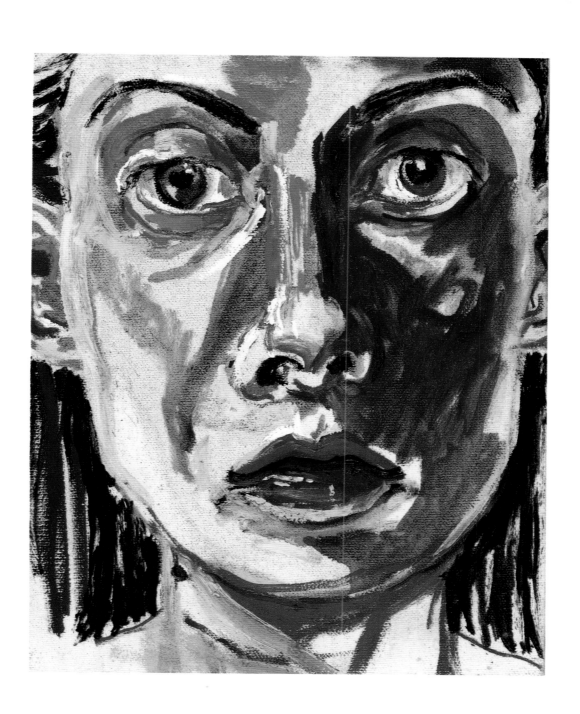

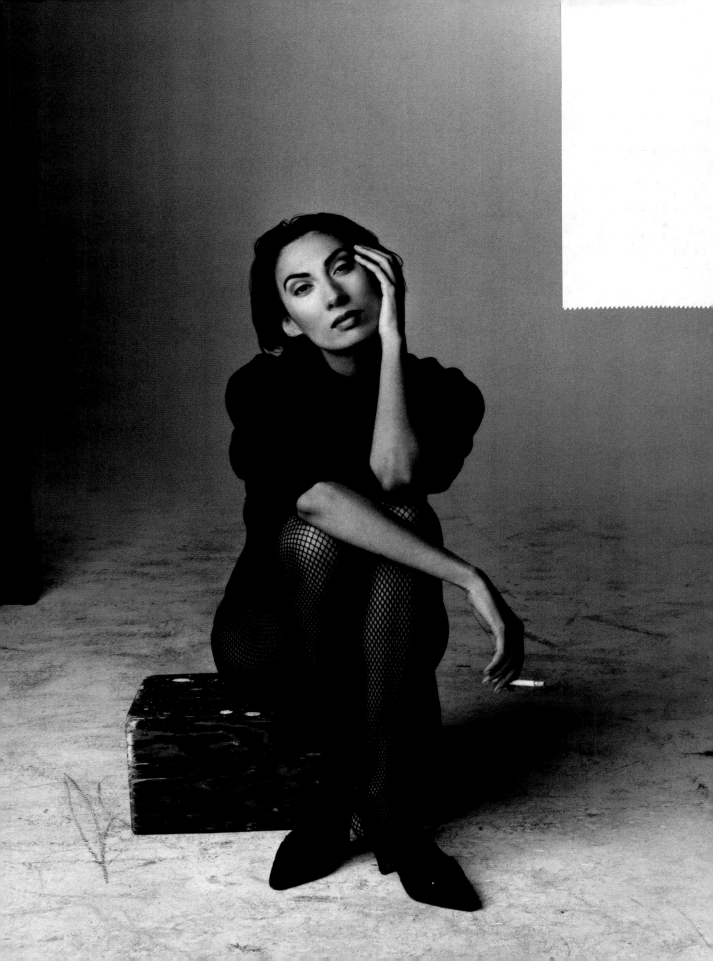

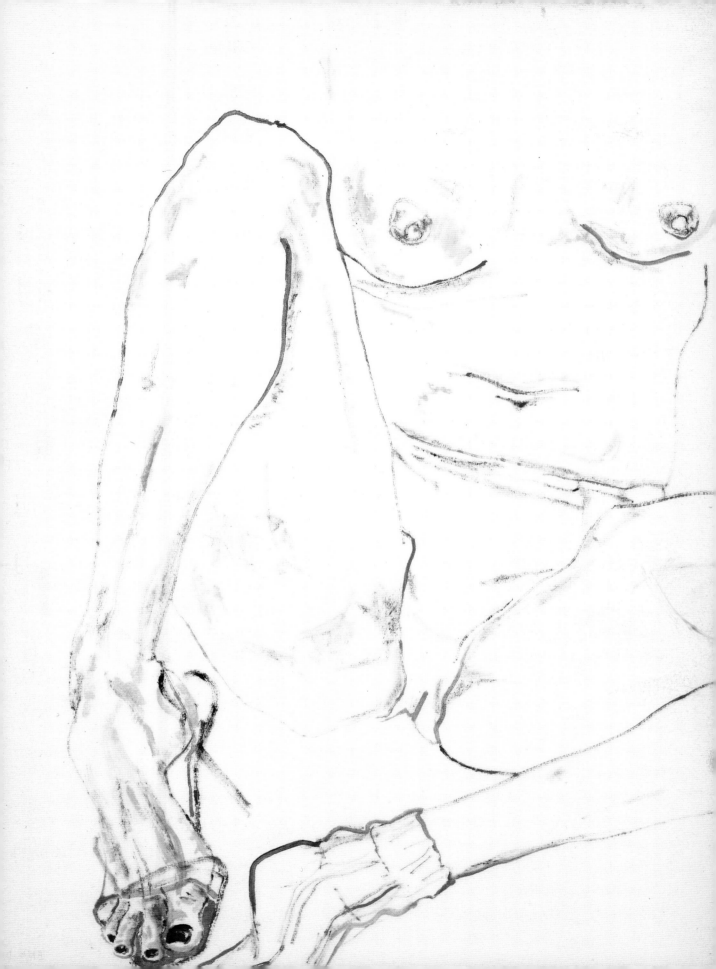

Christian Lacroix

I first met Anh Duong in the early or mid-eighties, in the studio at Jean Patou. I remember she was wearing a high-waisted sailor's coat, a "Breton"-style cap tilted back, and a tiny bag like a minute school satchel. At least that's the picture I have of her now: of a reserved, aloof, explosive little girl. My wife had spotted her one day at Hermès and sent her on to me.

I was looking for unusual-looking, very individual girls, like Marie Seznec with her hair white, for my permanent couture room, which was still obligatory then, and also to present the collection at the twice-weekly in-house salons. So Anh—her name was still Thi Anh at the time—joined us and after a while I noticed some hilarious caricatures on her dressing table in the 18th century/1920 room in rue Saint-Florentin. They had a highly personal brand of humor: deadpan yet "laser" at the same time, incisive but never malicious, funny but never grotesque. The first time Carrie Donovan came to one of the weekly salons, she asked for my favorite model. I immediately had Thi Anh wear a sheath dress in transparent lace embroidered in turquoise at the strategic places, with a taffeta twist and an embroidered egret-style hairpiece. It was my version of *Les Indes Galantes* and the first photo of my work to appear in *The New York Times Magazine*. Several months later, after a show we did in Beverly Hills, Thi Anh left us to go and work with Julian Schnabel. It wasn't until years later, when I dropped by her place in New York to say hello, that I discovered what had become of the little drawings in the rue Saint-Florentin. I'm referring to her large early portraits, that whole gallery of characters: so true, so clever, precise yet sketchy, robust yet fragile too. Each image was like a freeze frame of someone's soul and manner, that Anh Duong had captured with a sure yet feverish and agile touch, with a wildness that she had subtly, matter-of-factly appropriated for herself, yet which has the boundless determination one finds in today's self-portraits, whose gaze is as piercing as the Fayoum portraits.

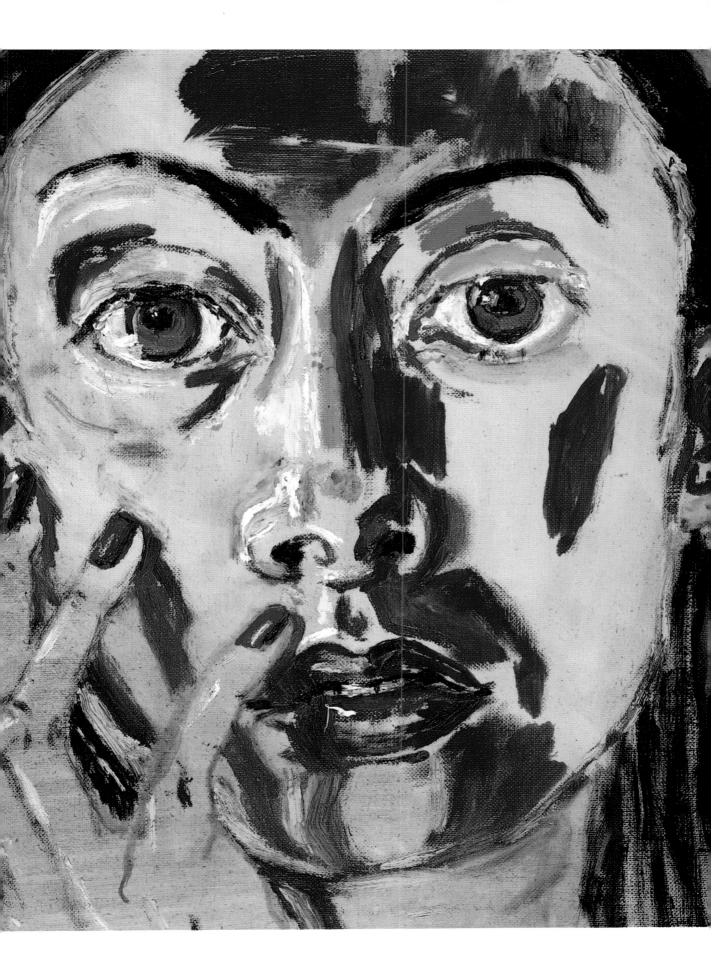

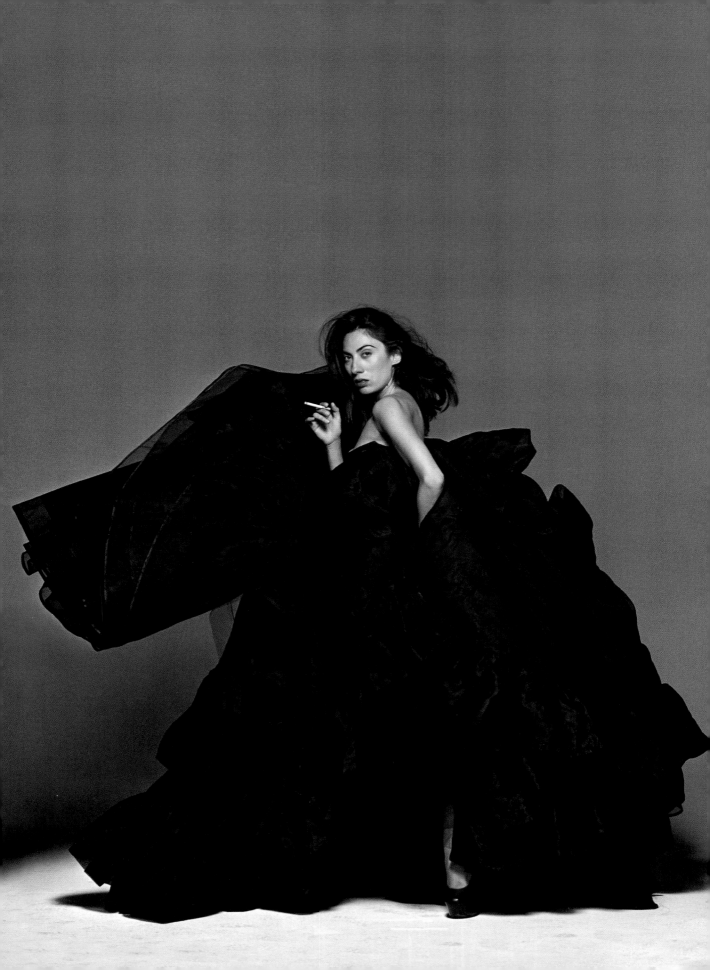

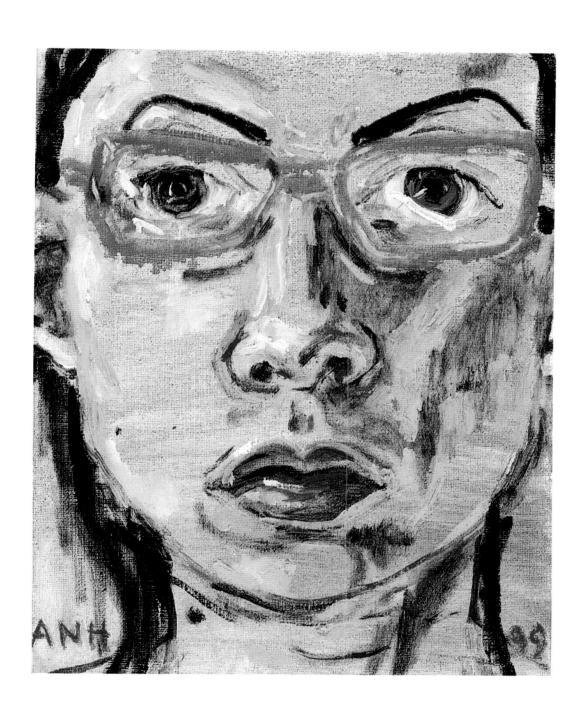

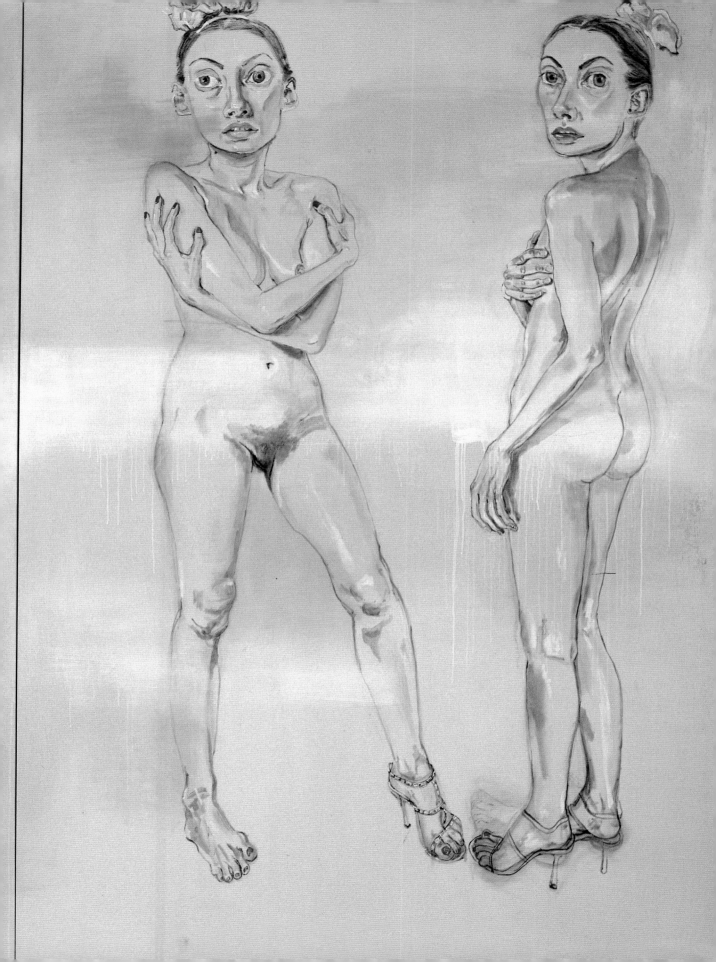

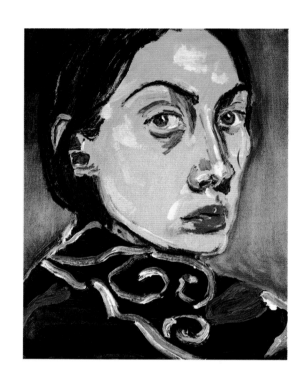
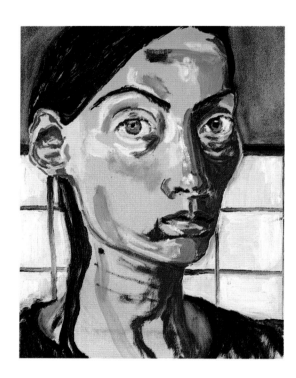

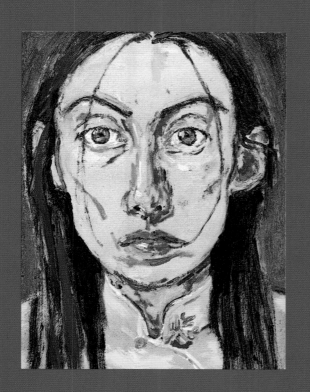

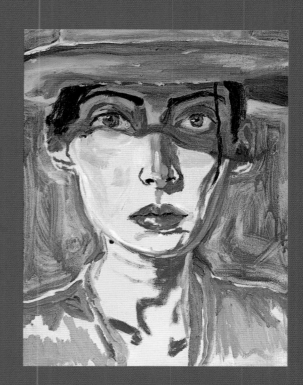

55

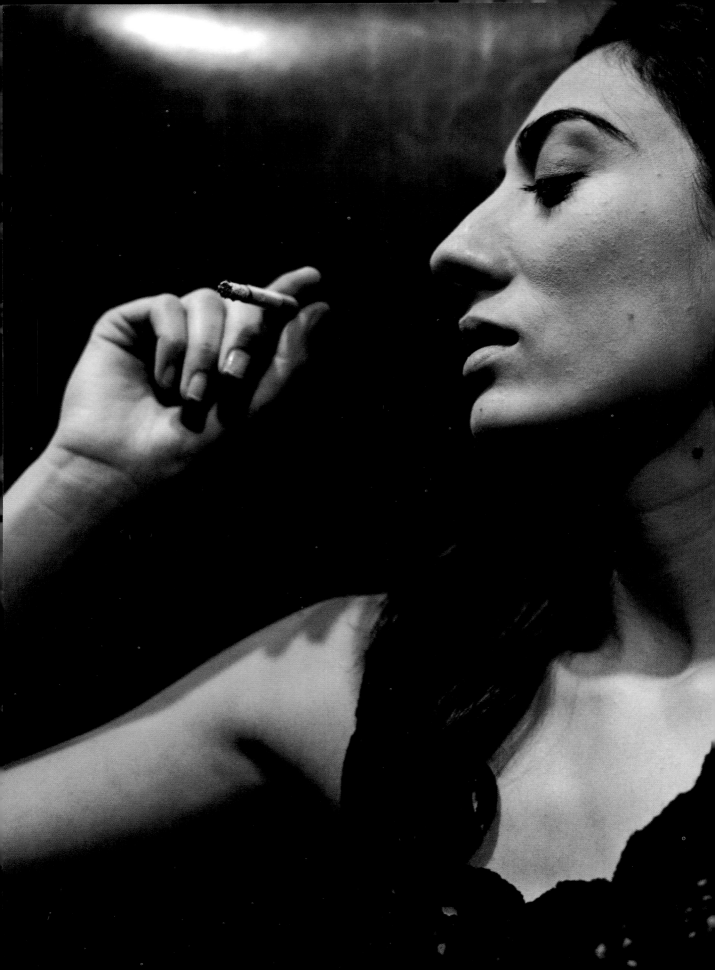

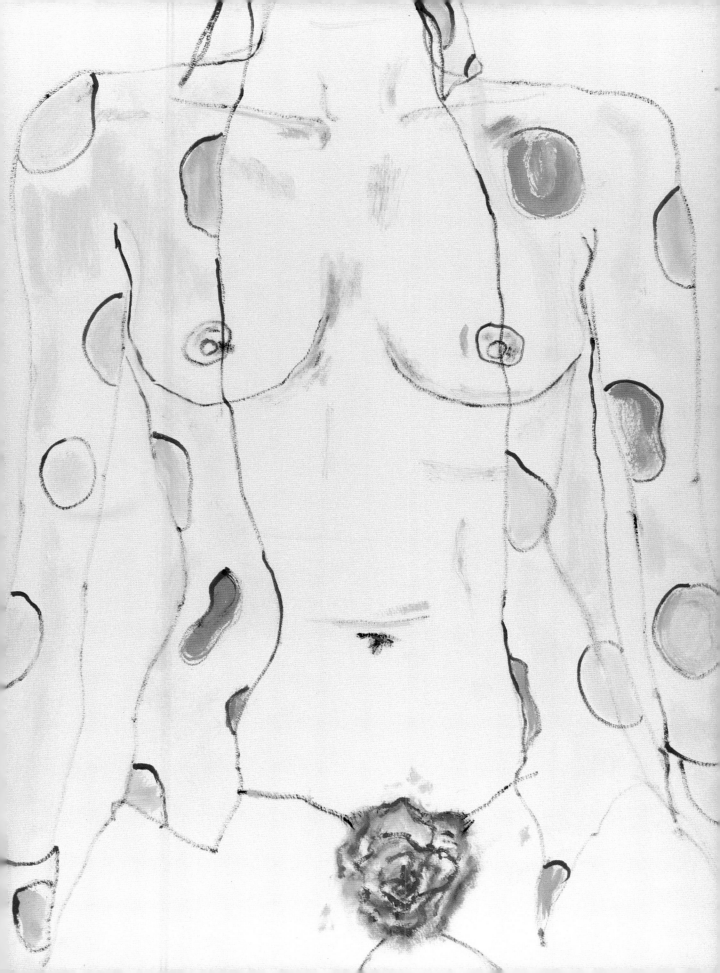

Eric Fischl

Portrait of the Artist Model

She starts with her left eye.
(That is not where I would begin.)

She paints from the top to the bottom.
(I move differently across her surfaces.)

She dresses herself up.
(I would remove her things.)

I see what I want from her.
(She shows me what it feels like to be.)

The object of everyone's desire.

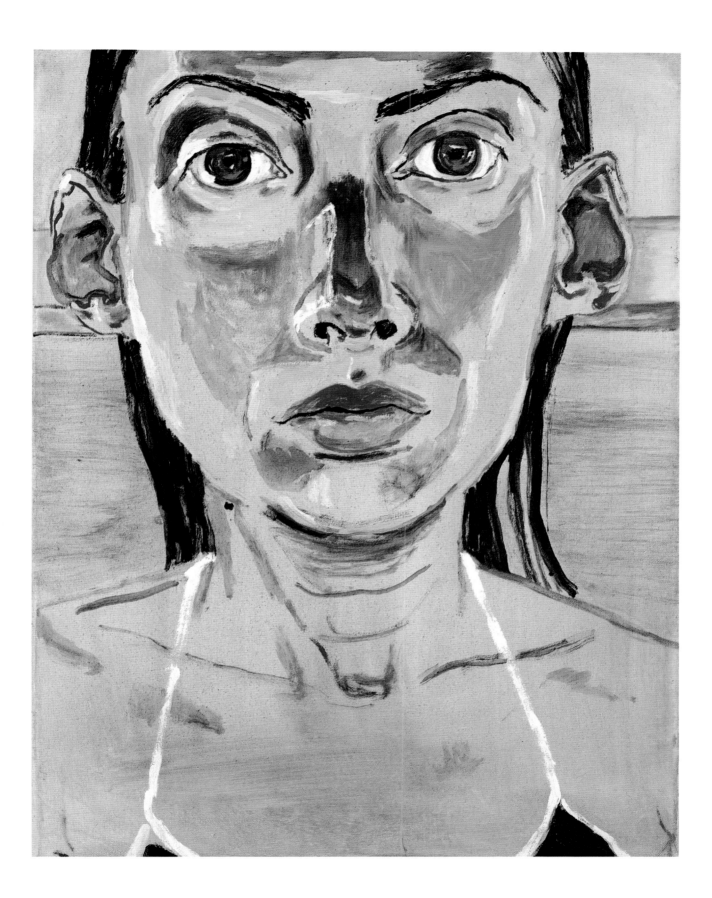

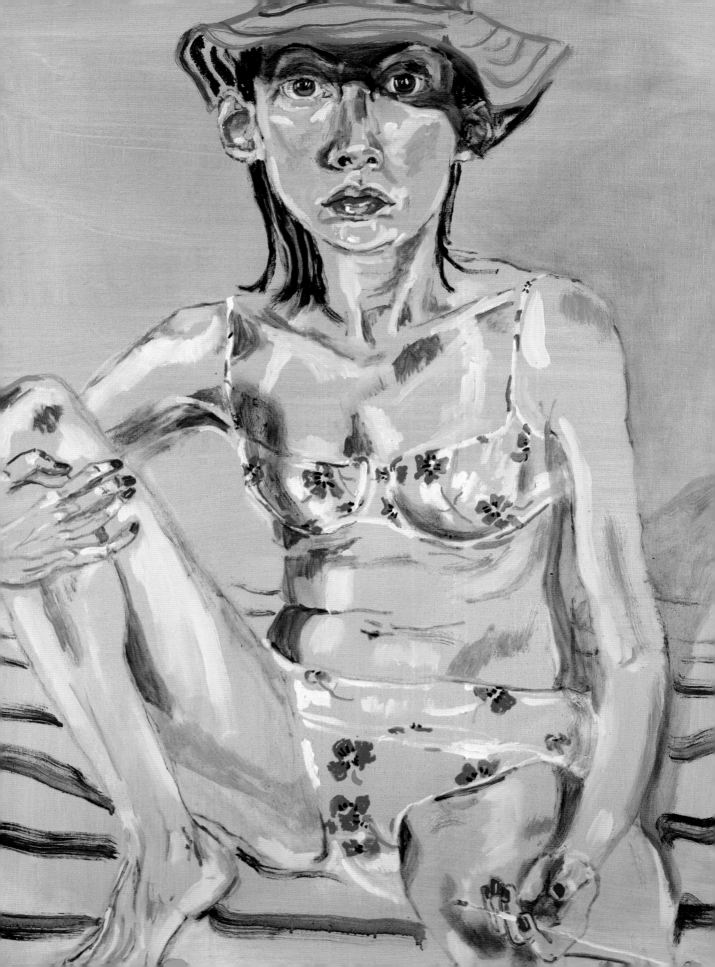

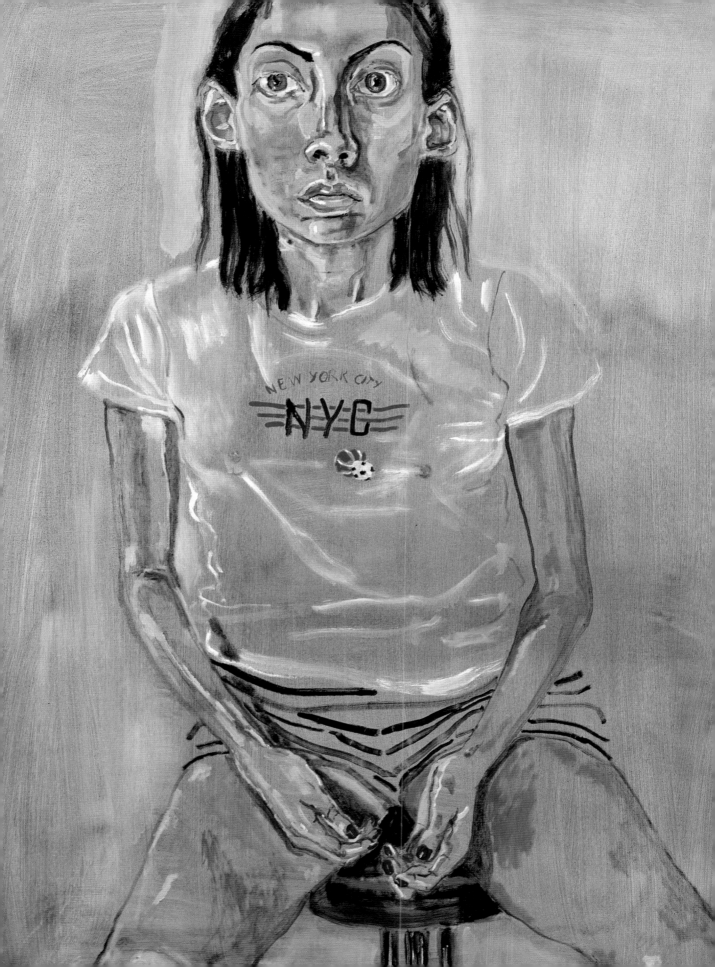

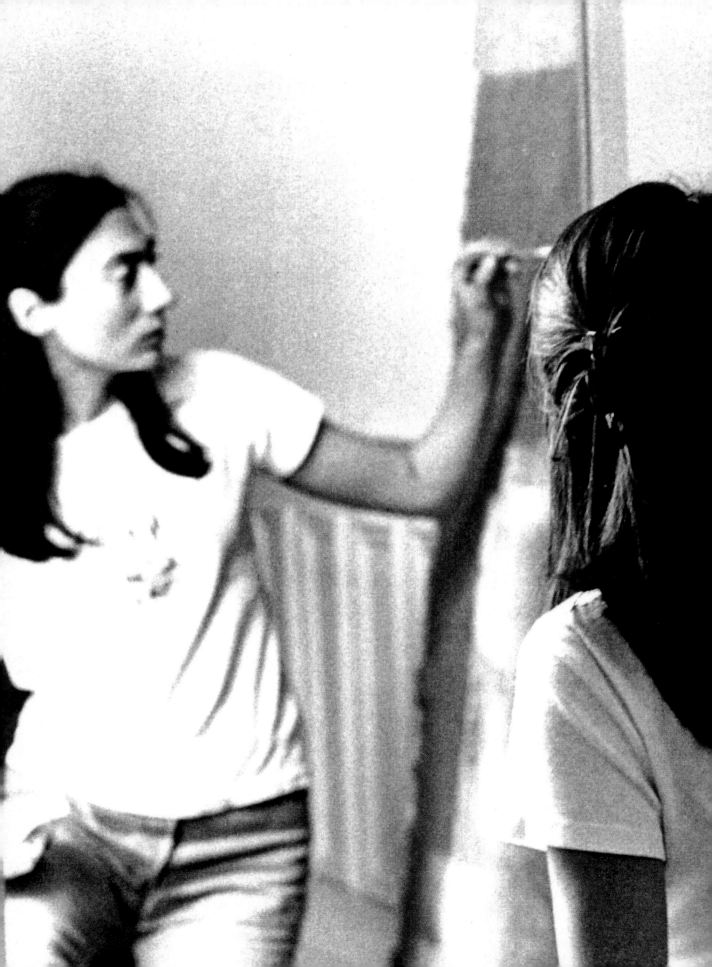

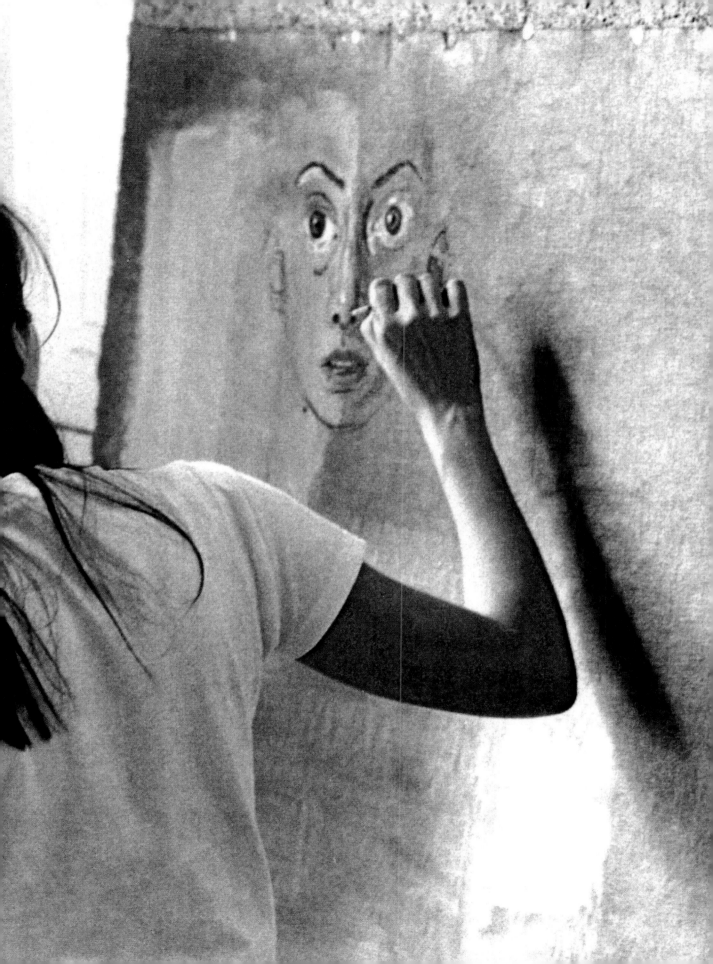

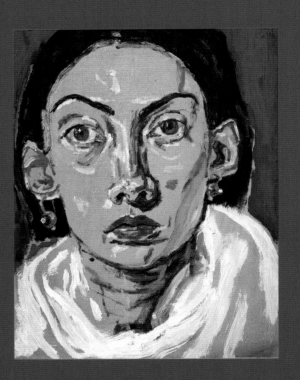

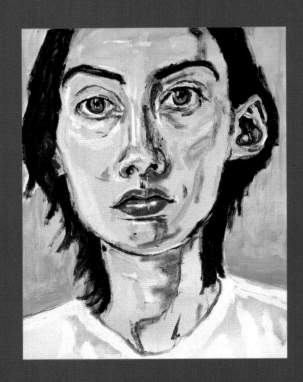

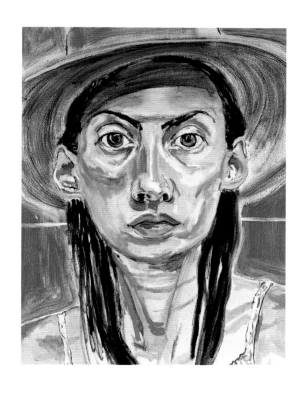

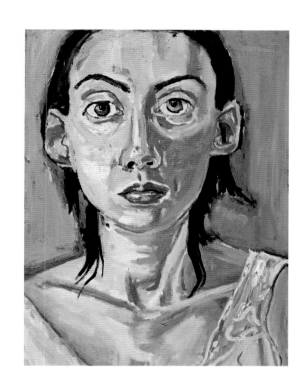

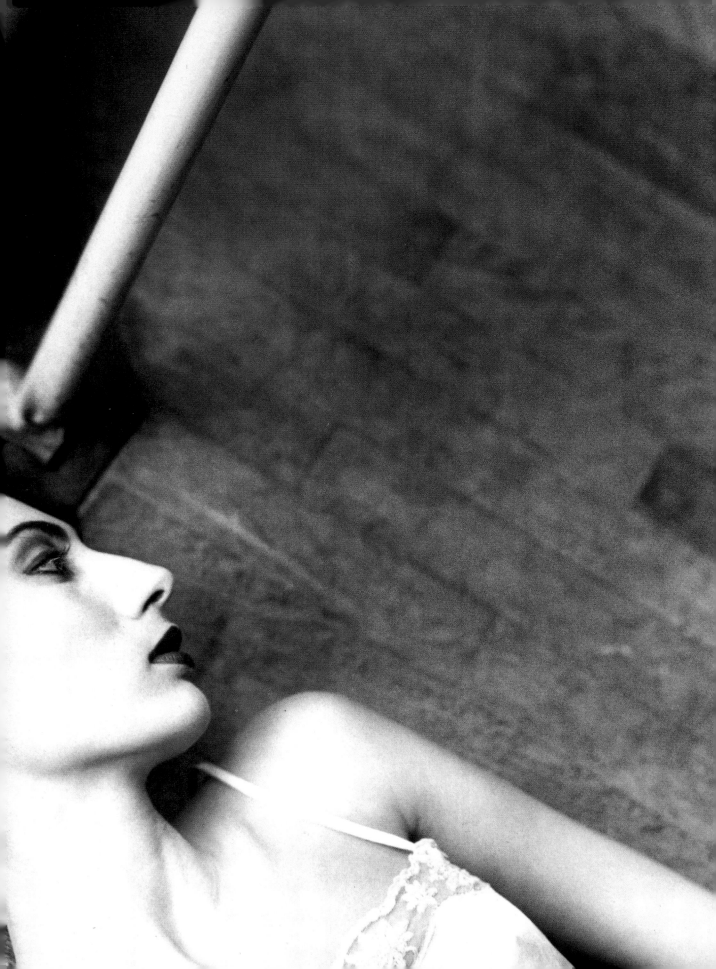

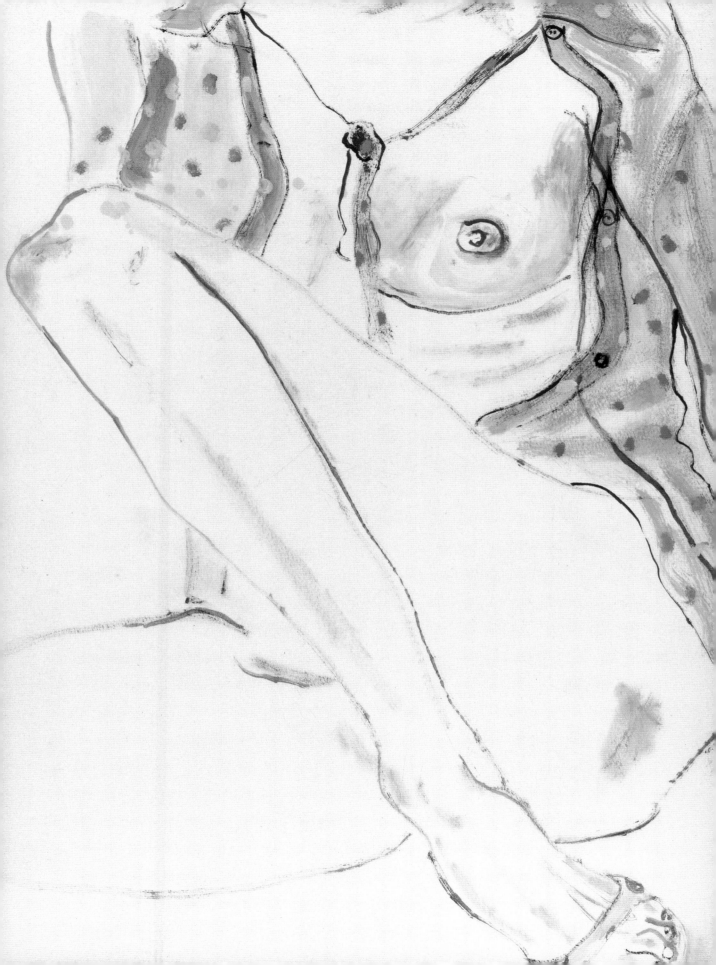

Diane von Furstenberg

I rang the bell at noon.
She welcomed me with a smile.
Anh and I have been friends for a while,
but that day we were both intimidated:
she was going to do my portrait.
A big white canvas had been prepared,
I sat on a high stool and looked at her.
She was more beautiful than I had ever seen her—
no make-up, her hair pulled back,
wearing gray sweatpants and a T-shirt.
Calmly, she chose a brush, went for a little brown
paint and, with more assurance and precision than
I had ever seen, started to paint my left eye.
Her arm was straight, her concentration so strong.
I couldn't help thinking of a postcard I had cherished
for years: a photo of Picasso in a similar position.
I was no longer intimidated; I was impressed.
Very soon the eye was captured.
If there would be nothing else
on that huge canvas,
it would already be me. Anh is a true portraitist.
She observes quietly and transmits perfectly
with no fear and immense talent.

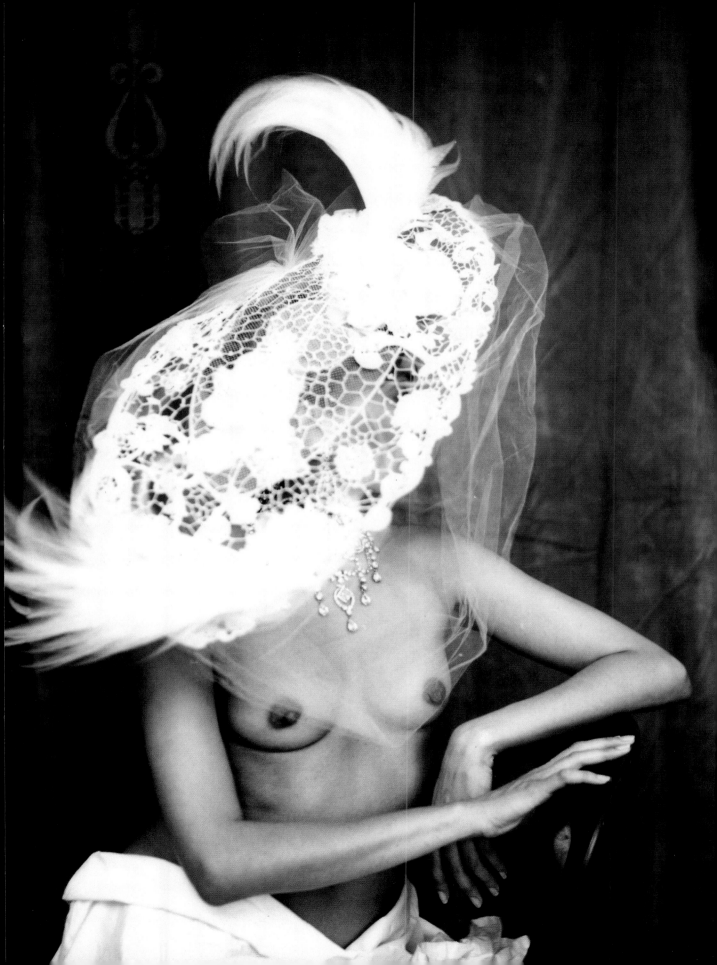

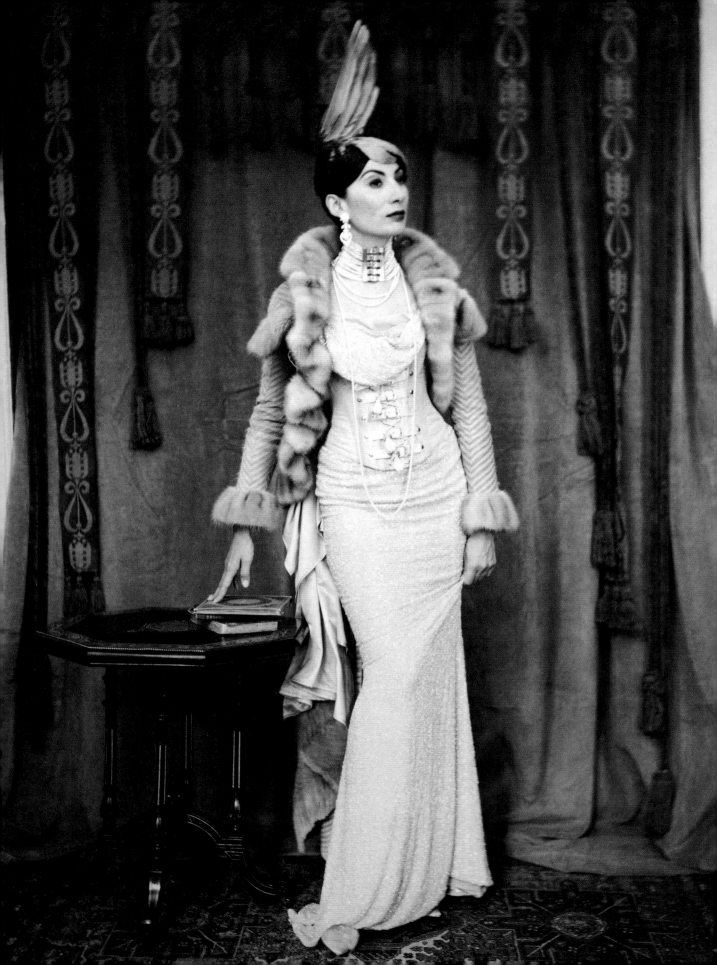

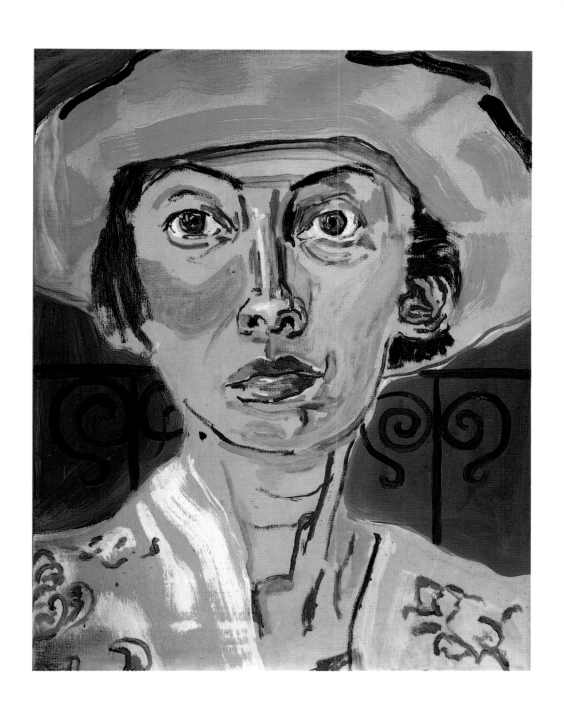

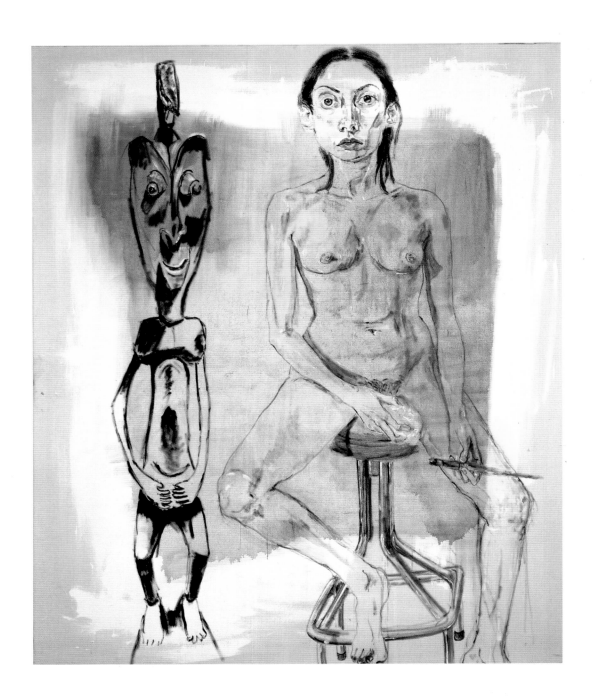

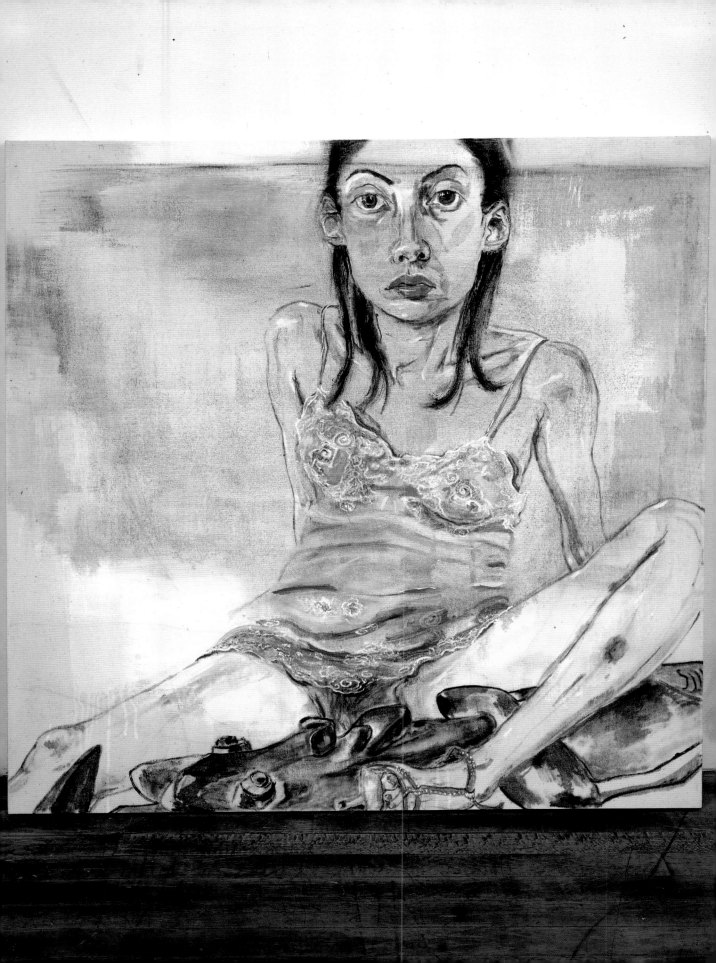

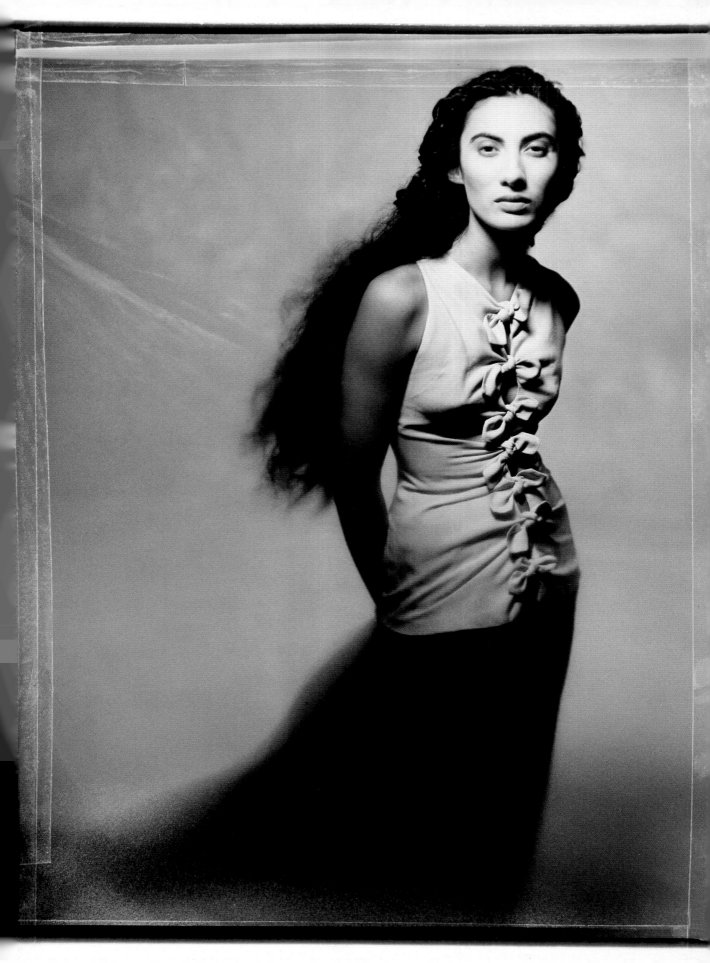

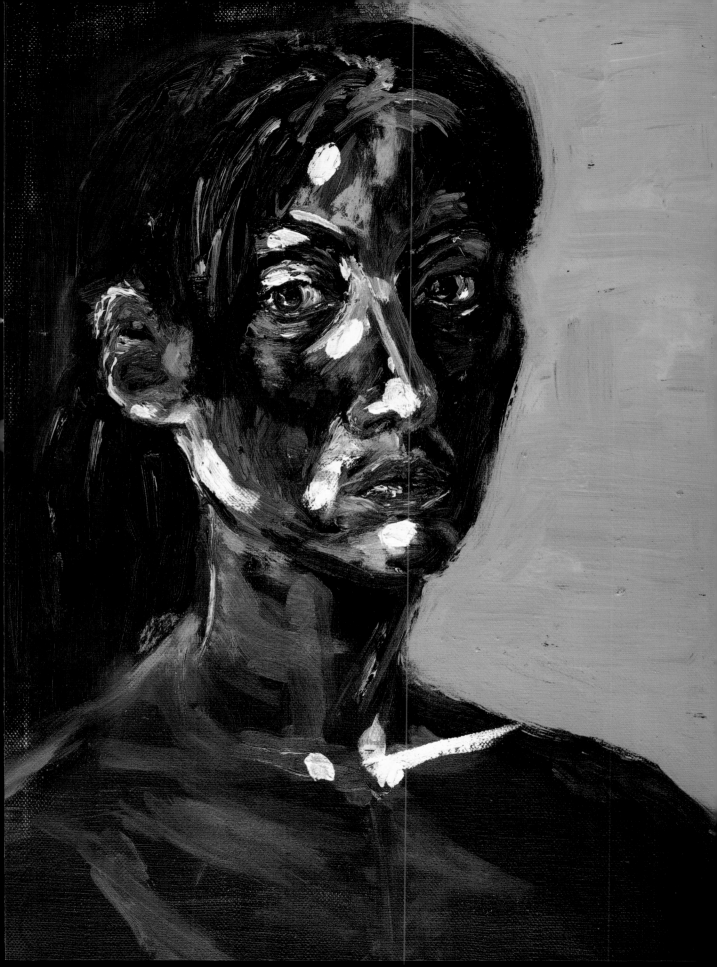

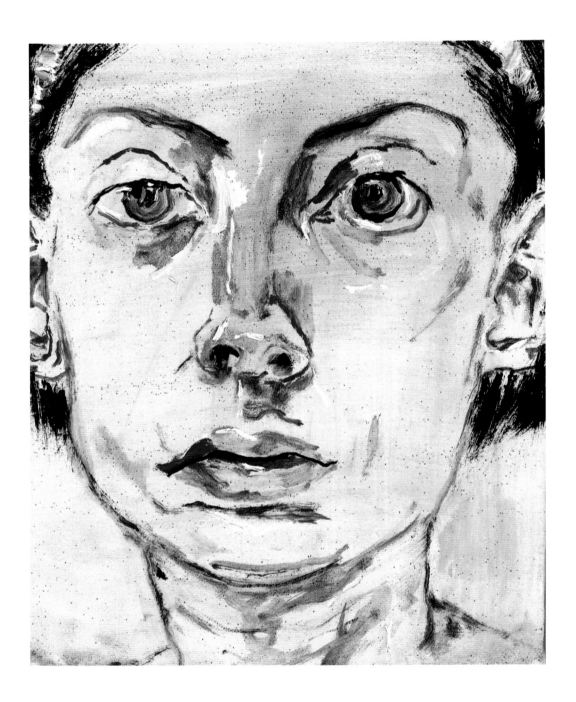

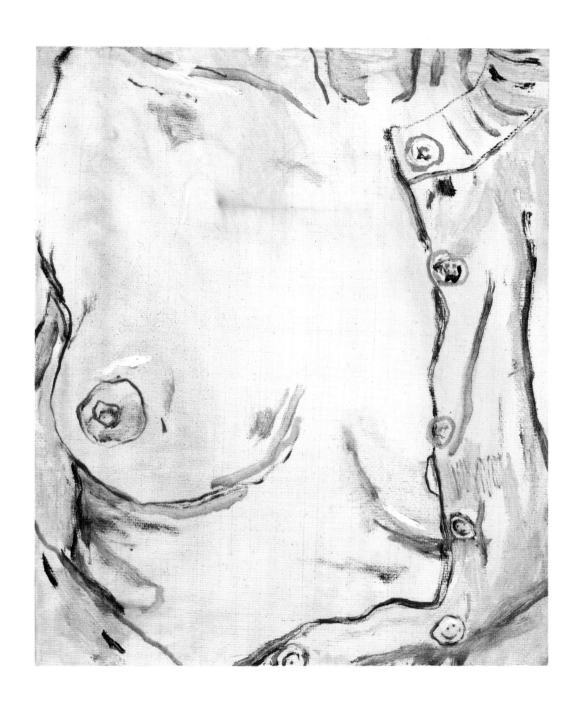

Julian
Schnabel

Painting is a diary—
a record of someone passing time, and marking it, abstract, figurative, realistic, objective,
subjective, recognizable, hermetic, monochromatic, shiny, dull, large,
small, antique, new, suprematist to folk art, all painting is a diary.
Painting's objectiveness and man-madness make them human barometers.
They have a symbiotic relationship with death. Portrait painting is the most obvious
record of time passed. People stuck in time, stuck in their lives,
are witnesses to the act of painting, to the act of being observed.
In the course of this relationship they become the ghosts who inhabit paintings.
I first came across Anh Duong's work in the late 1980s. For me, her paintings occupy a
singular place in the history of portrait painting. It is a place that
you can only occupy if you and your family are immigrants. The author of these works has to
be displaced and probably has genetically inherited this displacement.
It is almost impossible to draw in a way that has never been done before.
The drawing in these paintings cannot be learned.
The only way, is for art to come from a place that is so particular to you that no one else could
have done it. These paintings are original as paintings can be.
They have no affect. This work is not manneristic or decorative, it is not an automatic pilot.
It is not about style or techniques, there is a complete urgency and necessity to every mark in
each painting. She and her subjects are captured in life looking towards death through
the eyes and the semi-formed drawing of these paintings; in much the same way
that Antonin Artaud's portraits are notations of his intimate relationship with insanity; particularly
the ones done at the hospital of Rodez between 1946 and 1949.
Frida Kahlo's paintings might come to mind when viewing Duong's work. It is by coincidence
that these women both have dark hair and eyes. They both are prisoners of their own
self-portraits. There is a quiet scream in both these painters' work,
the similarity of appearance is similarity of temperament. It is silly to compare artists
but it is a handle on the pictures. I don't want to rob you of
the experience of really seeing these paintings, so look at them.

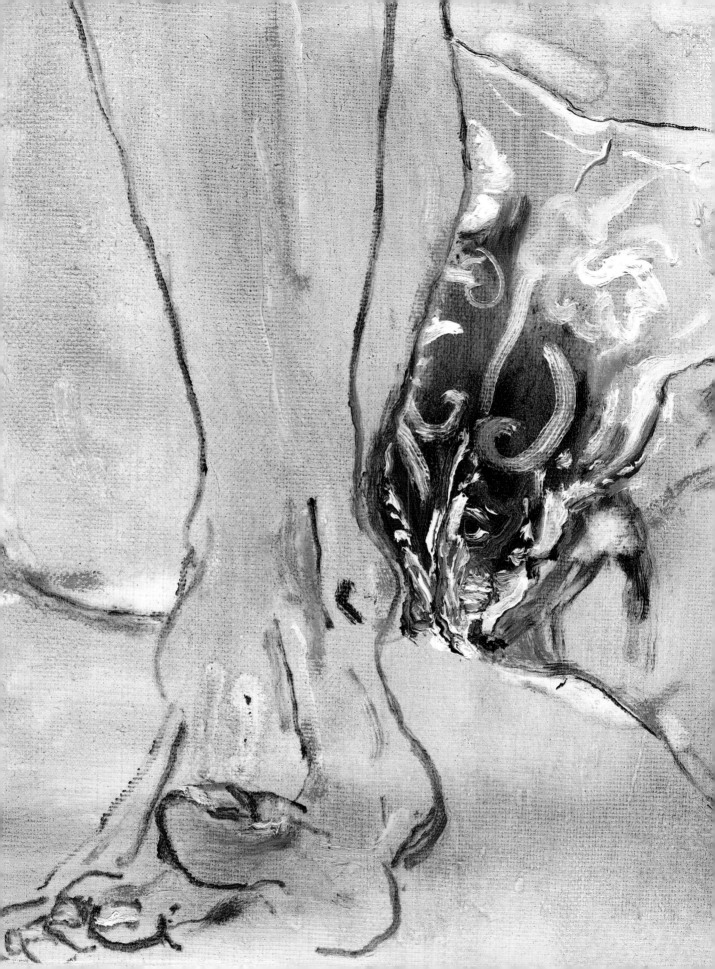

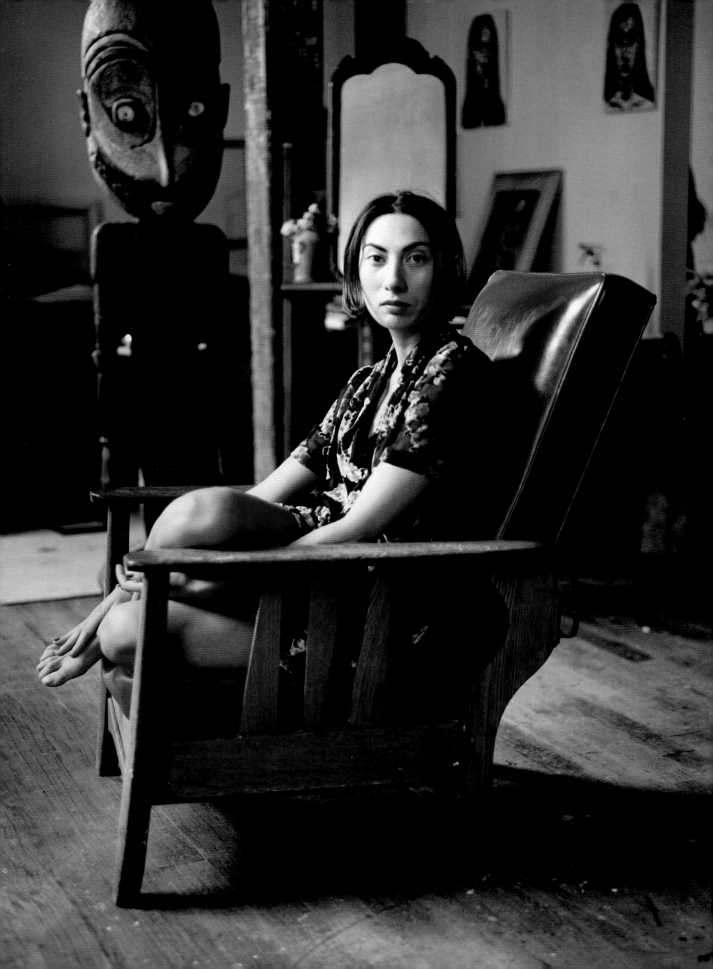

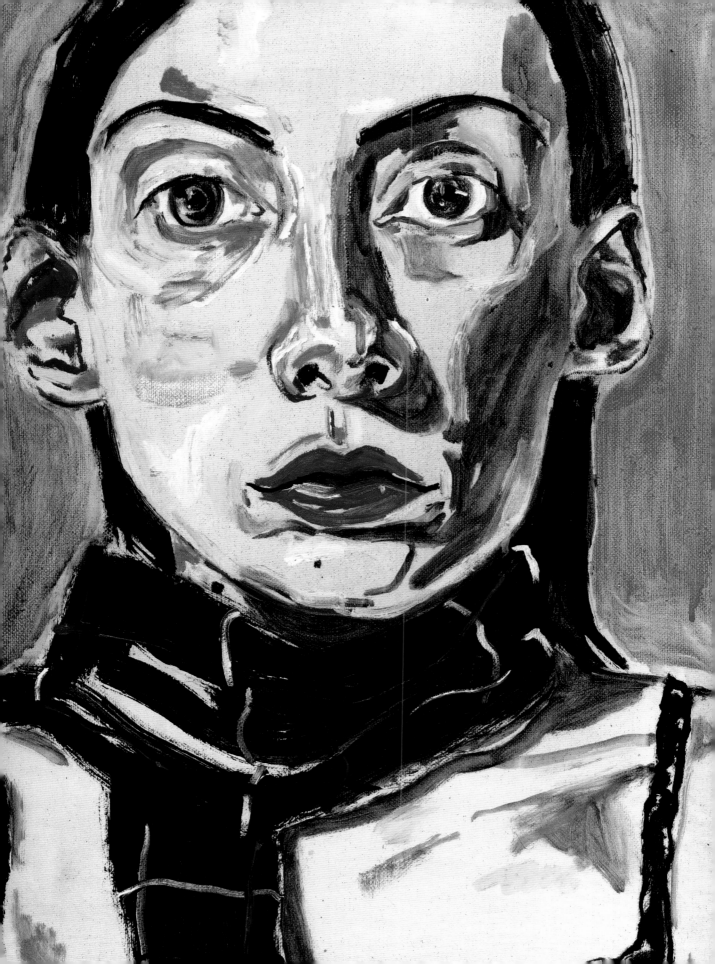

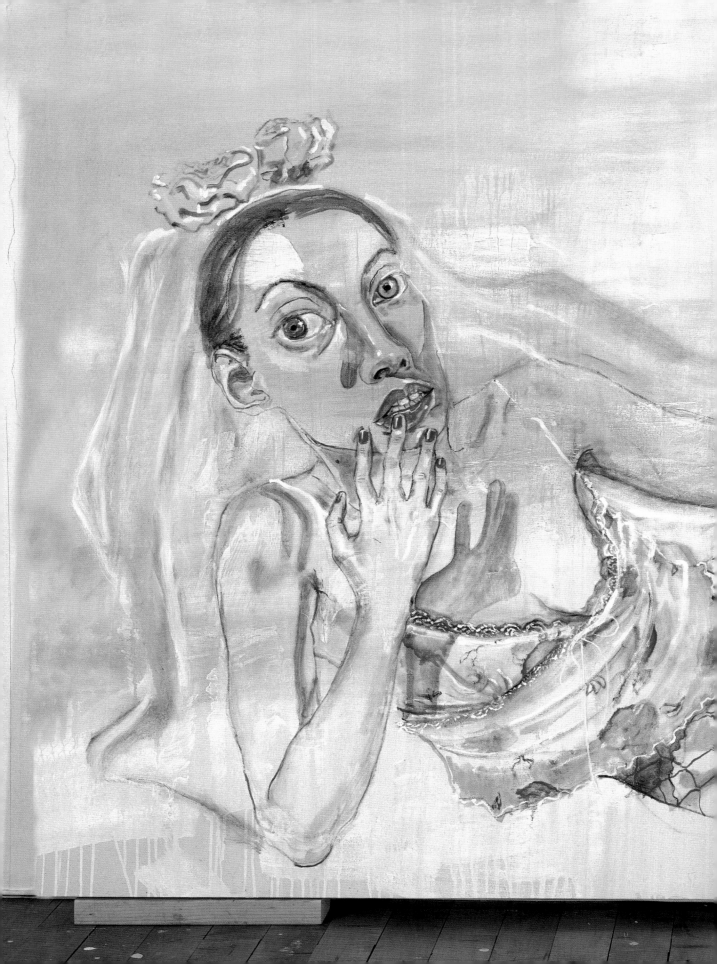

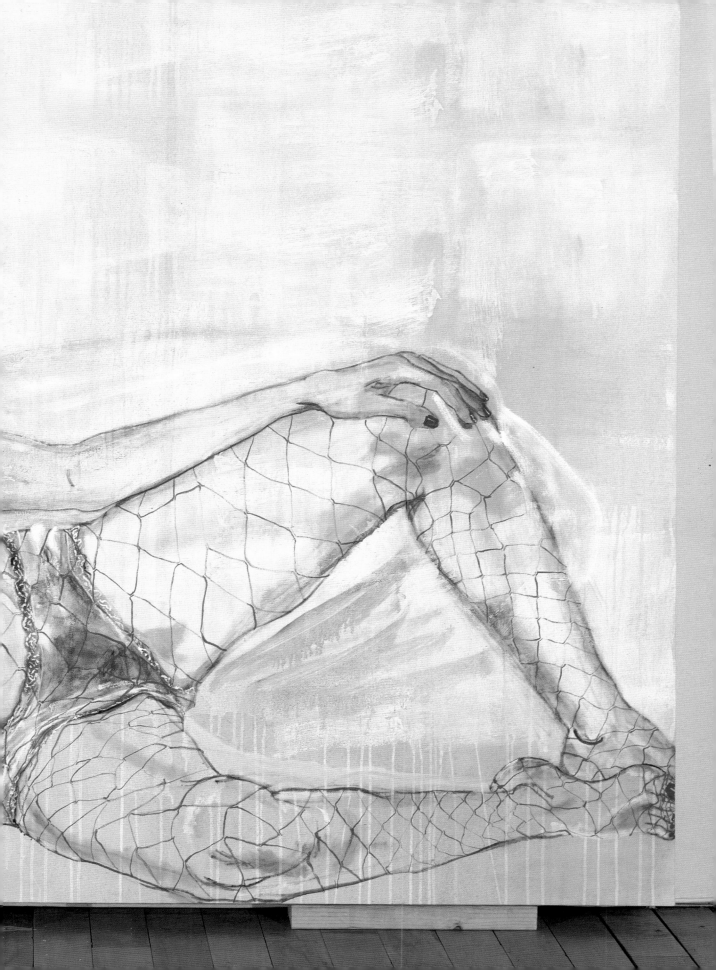

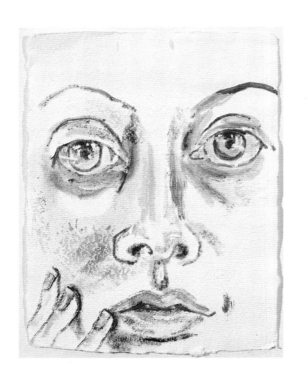
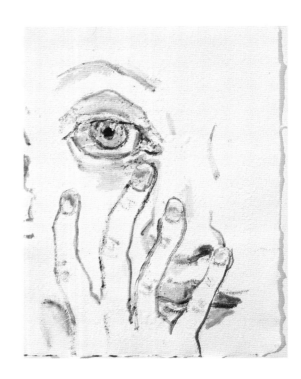

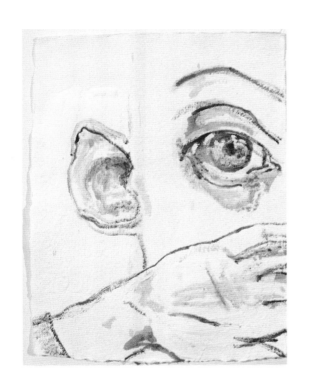
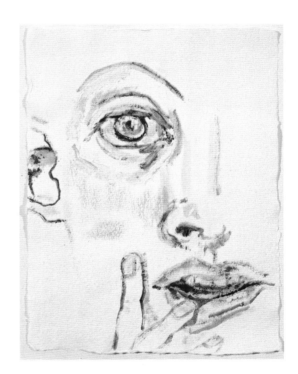

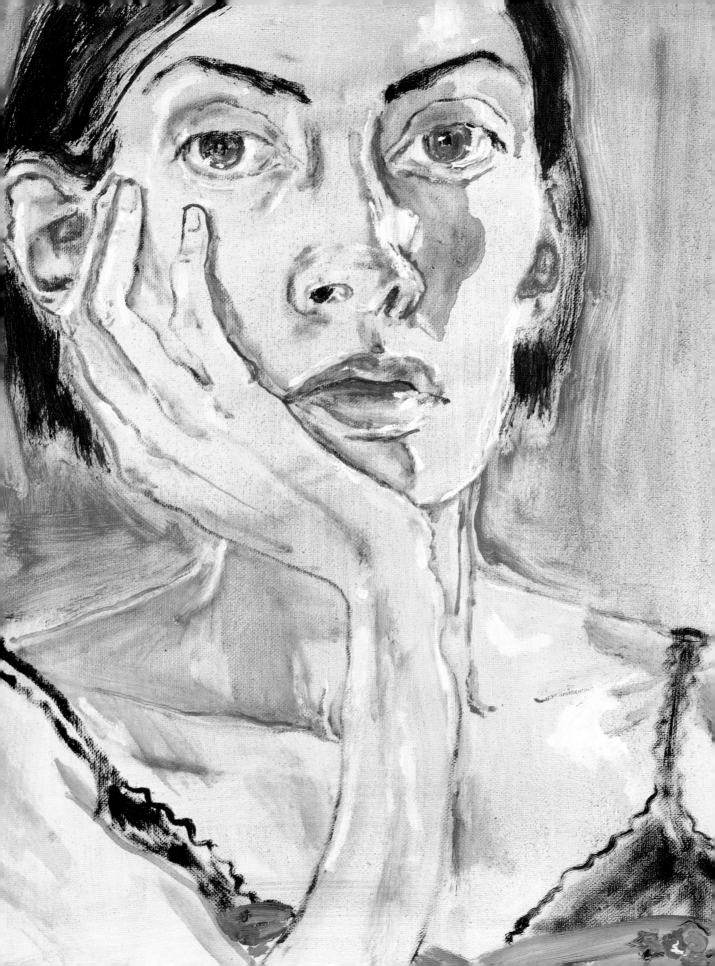

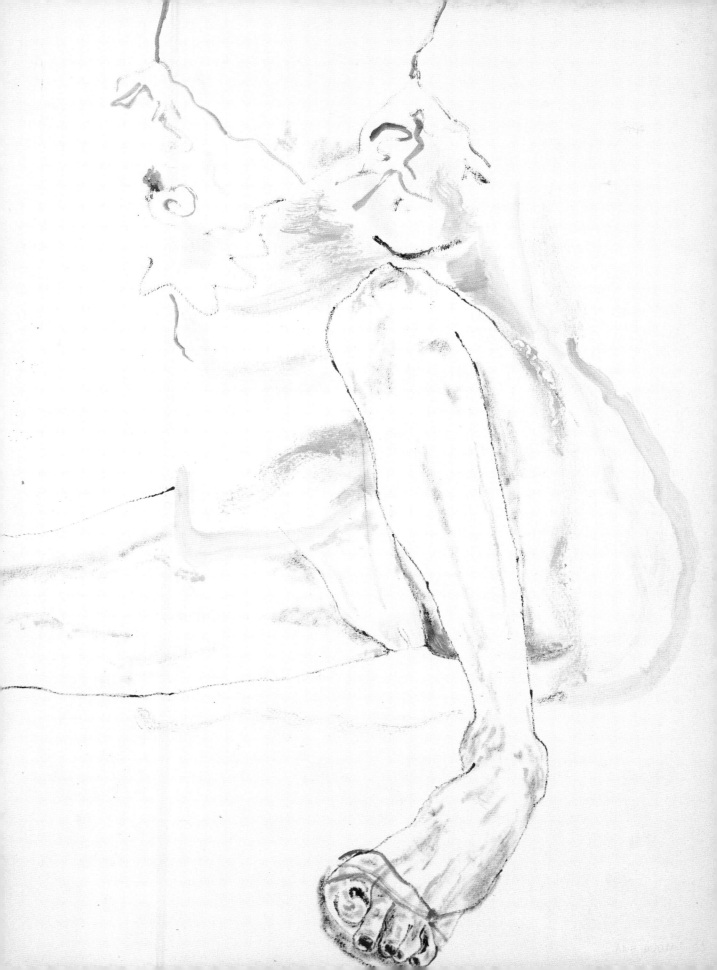

Ingrid
Sischy

When Ahn Duong began to be an artist, a lot of people were skeptical.
But it turned out that she was a genuine painter trapped in a model's body.

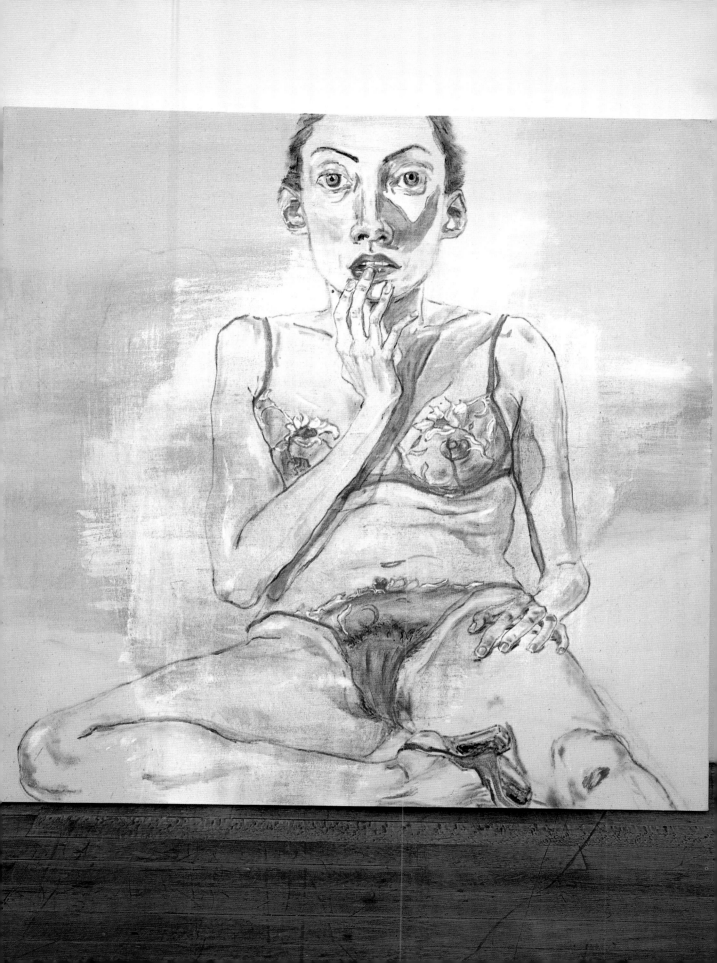

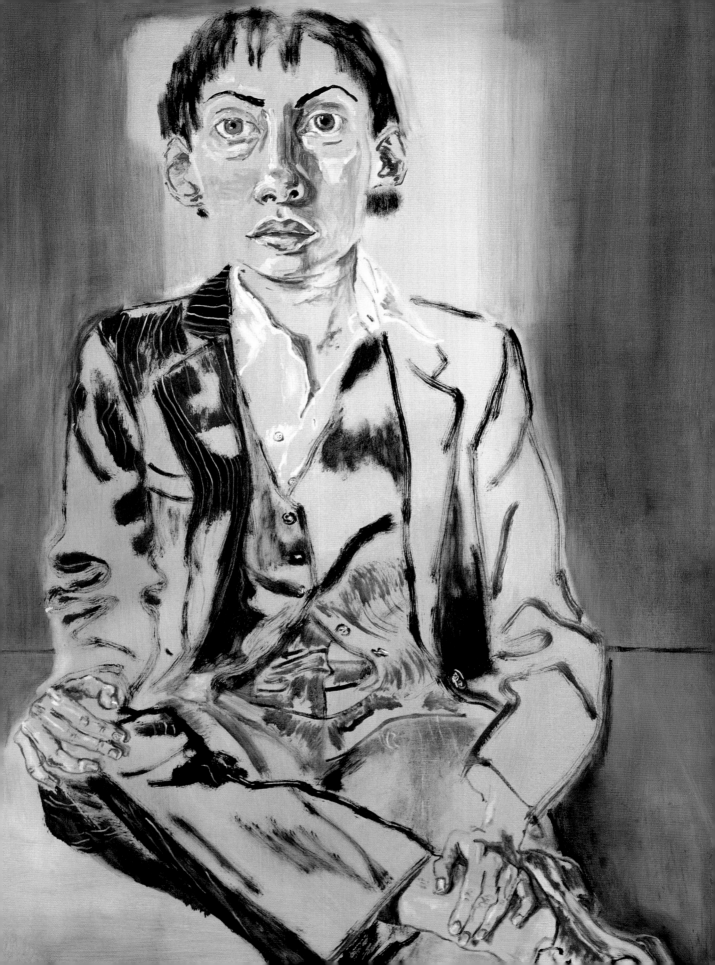

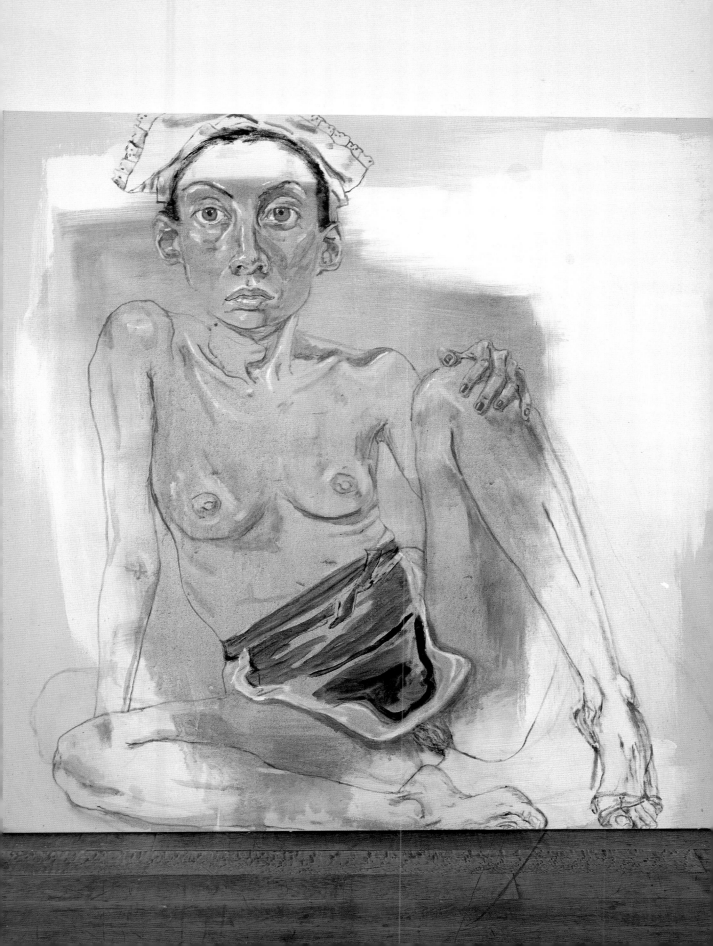

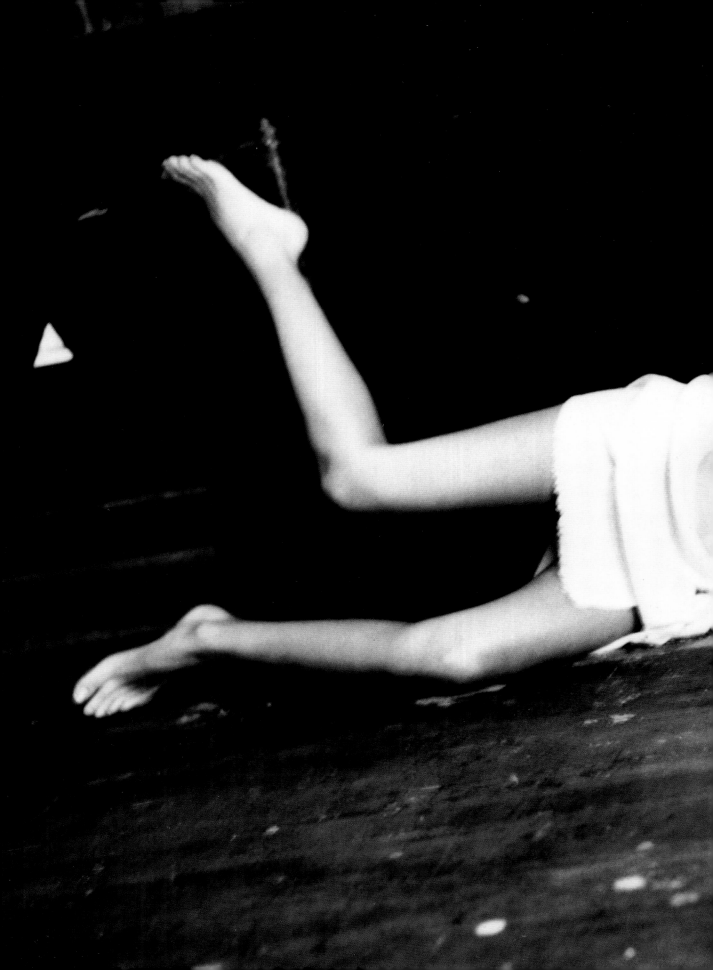

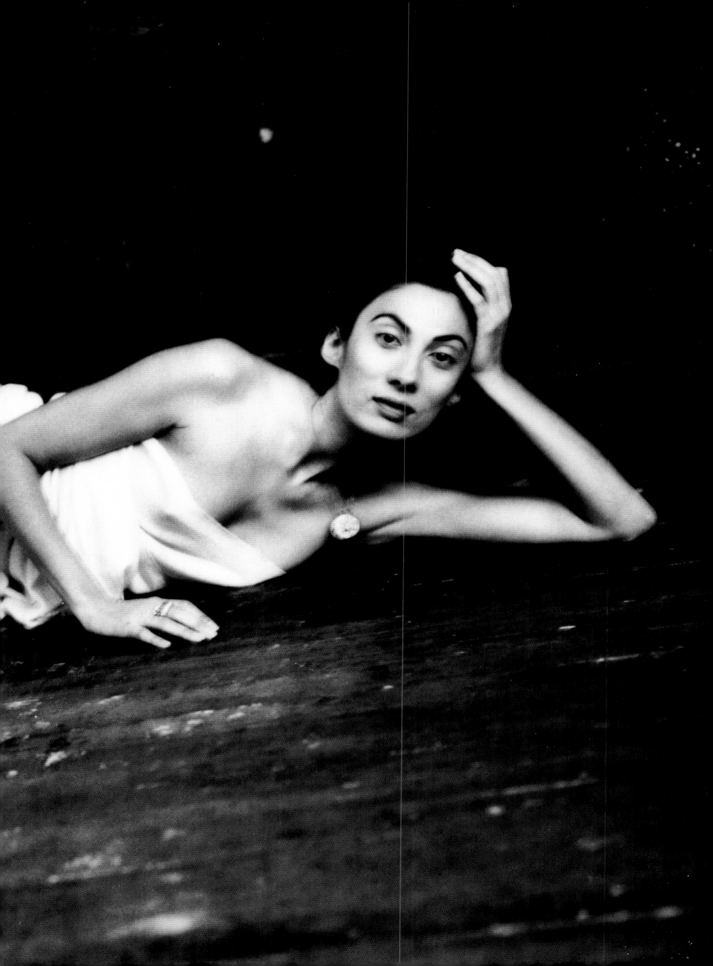

94

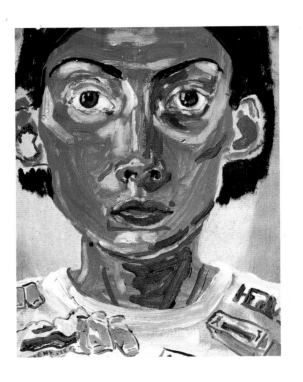 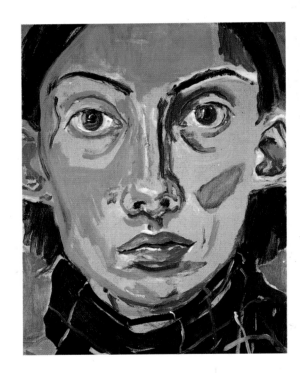

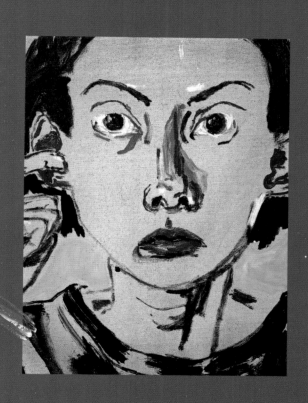

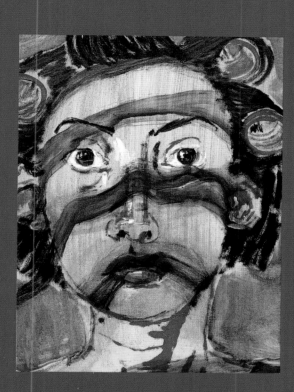

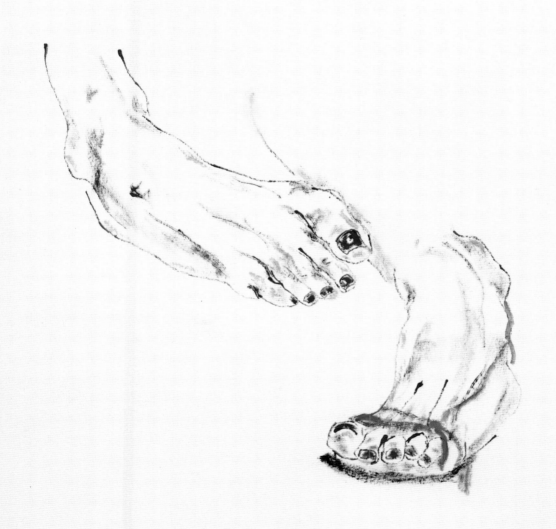

Laetitia Masson

Anh
my sister Anh
love isn't simple
life isn't simple
painting isn't simple
making movies isn't simple
but we're together.
From Boulogne to New York
then from New York to Paris
then from Paris to Le Havre.
Where I go you go
we leave in search of one another
you in you
me in you.

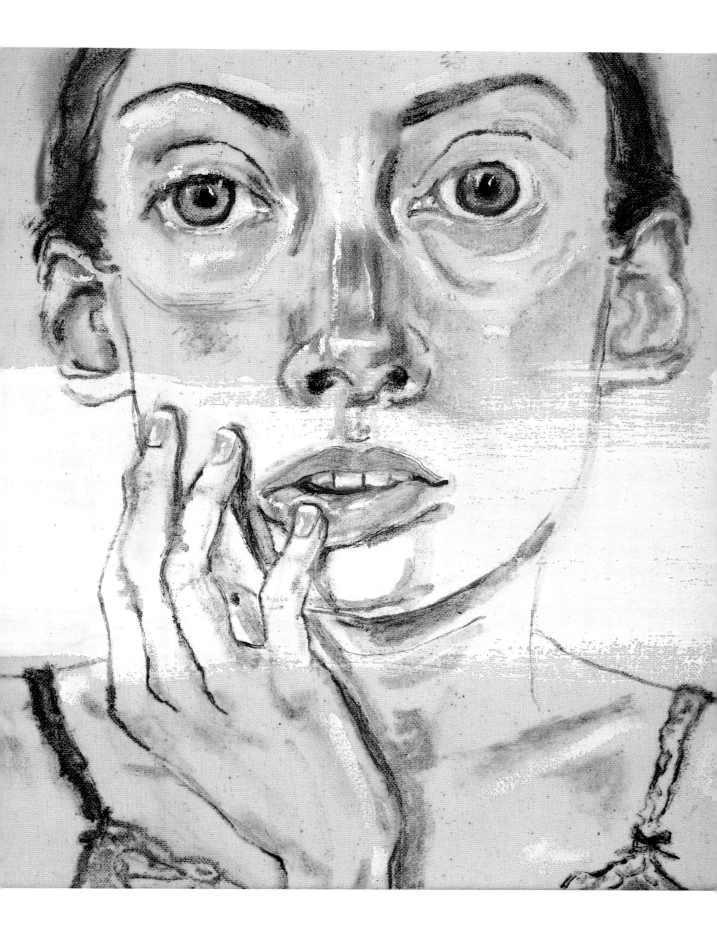

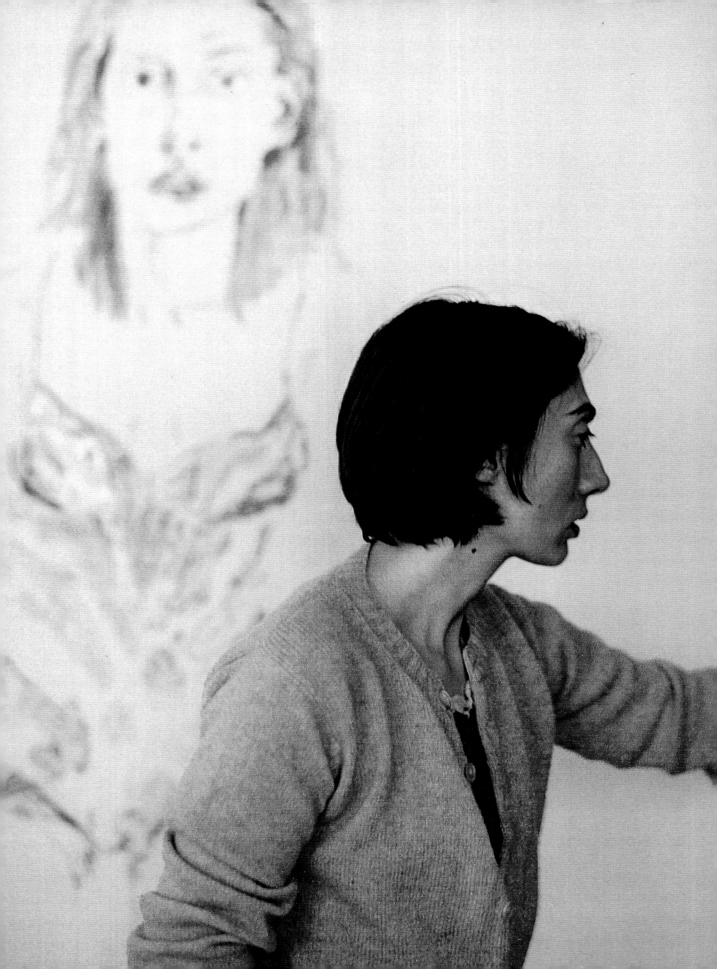

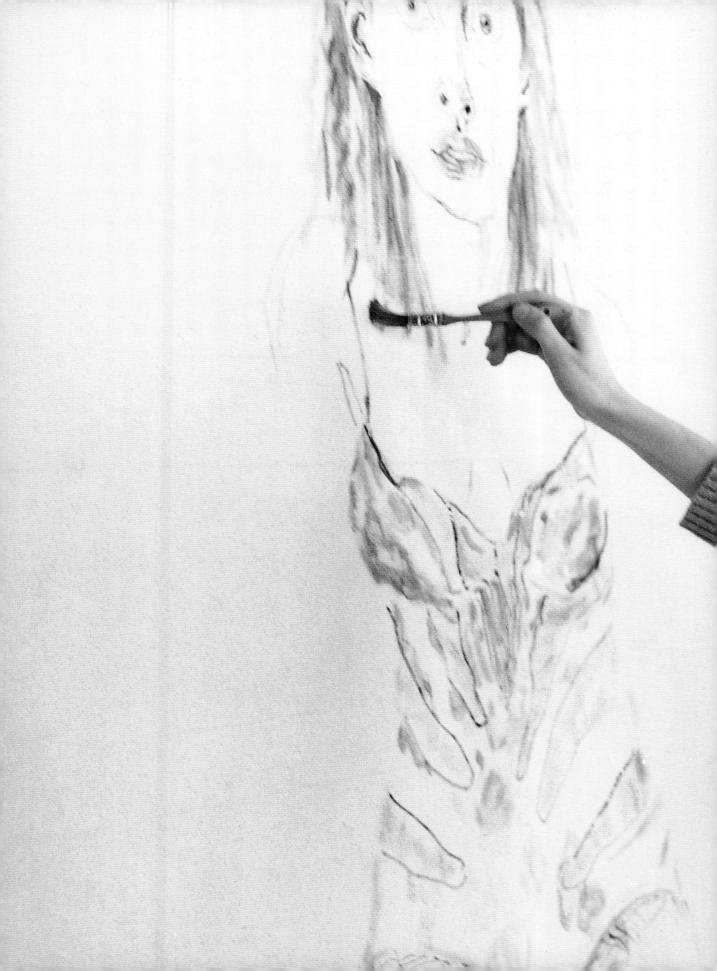

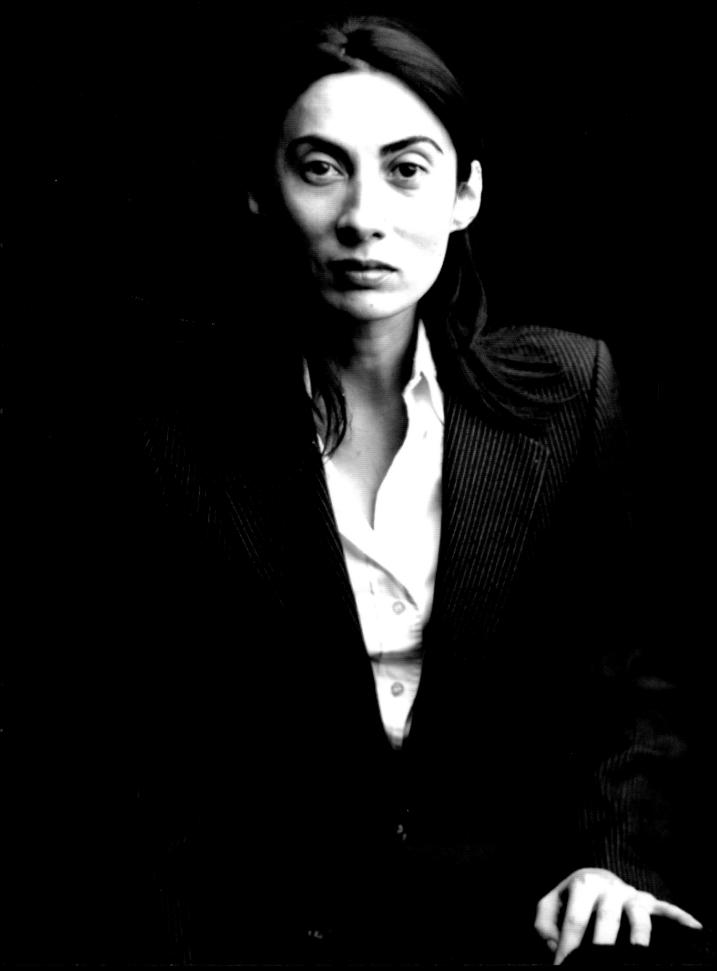

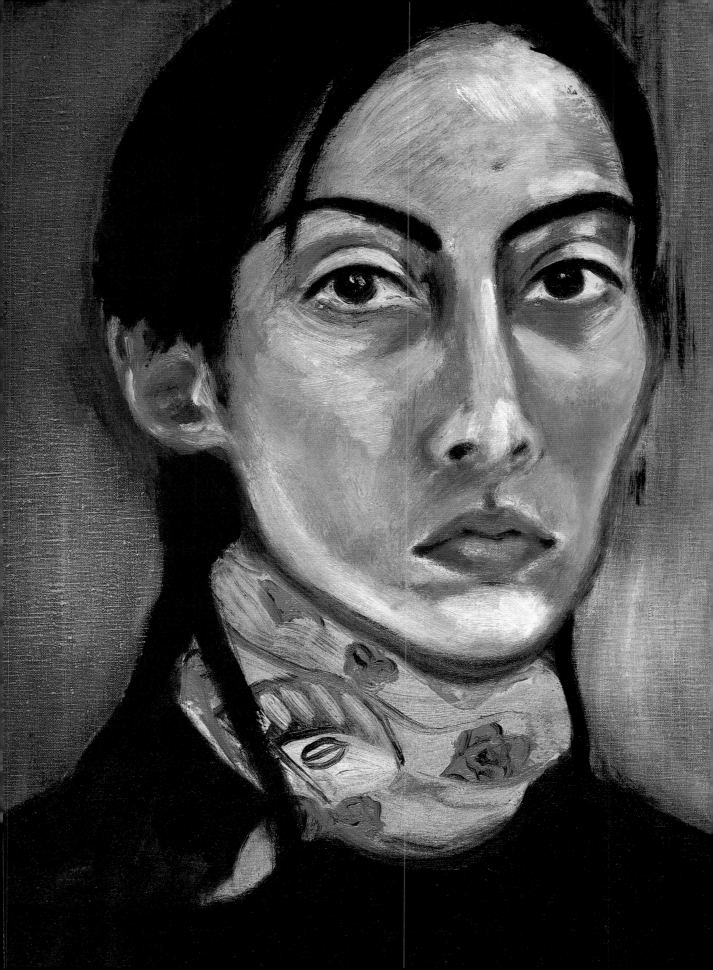

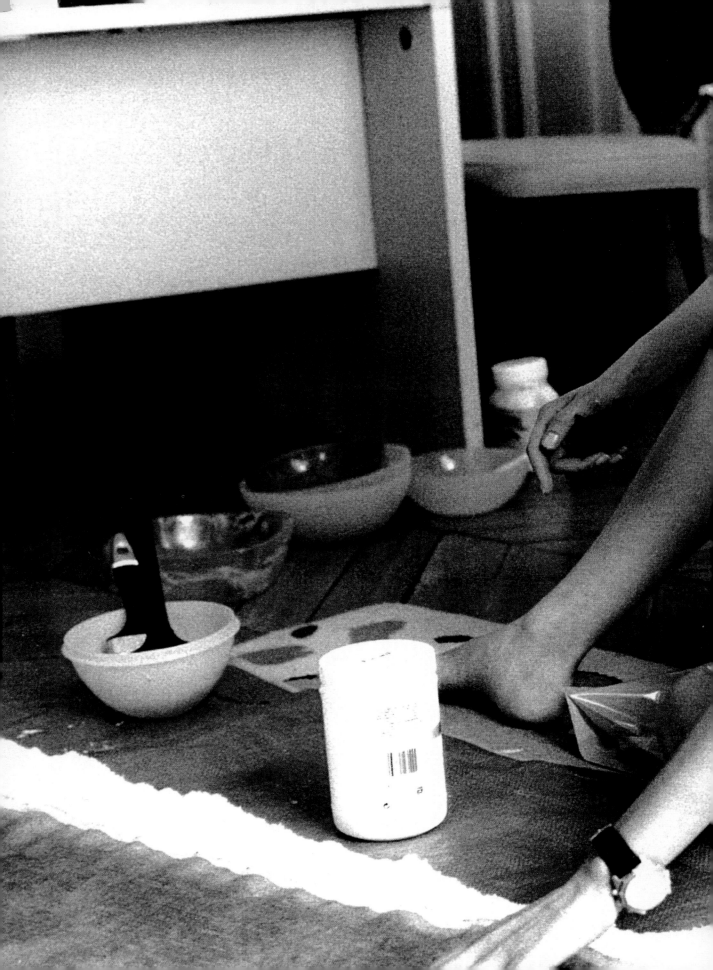

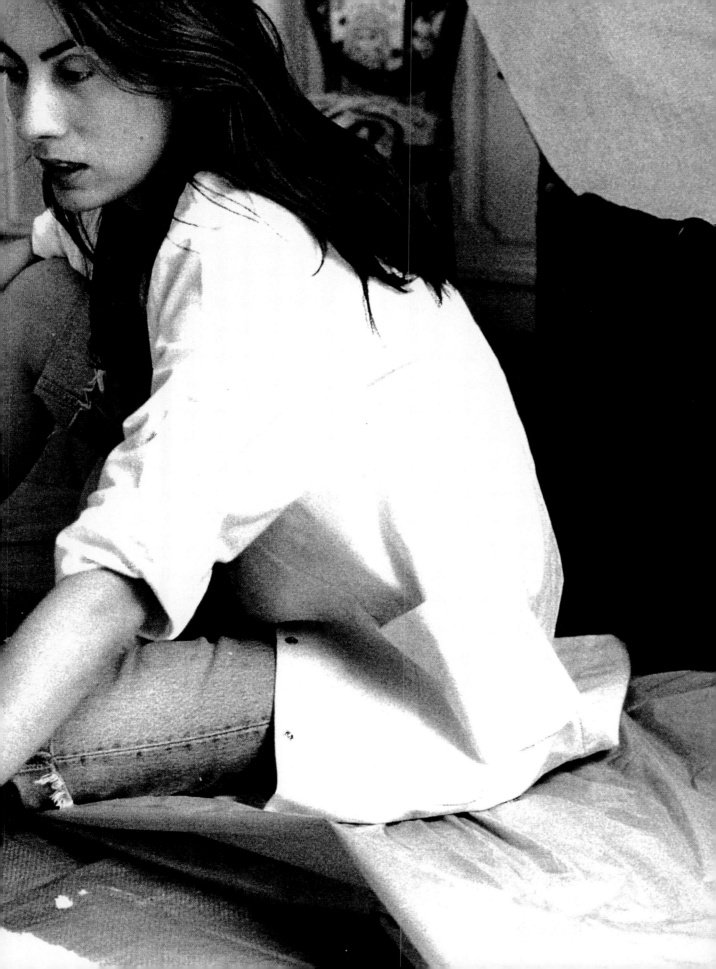

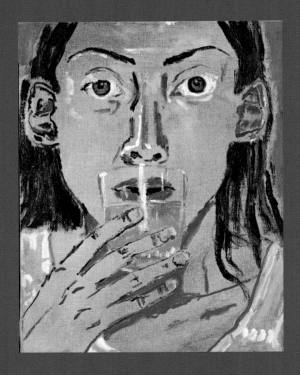

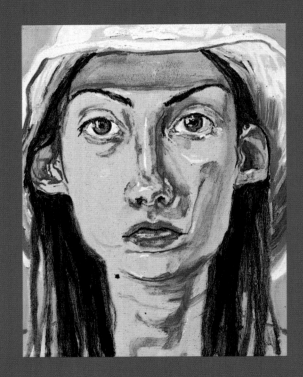

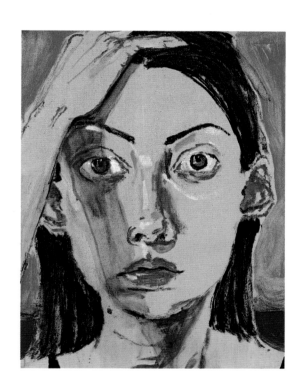

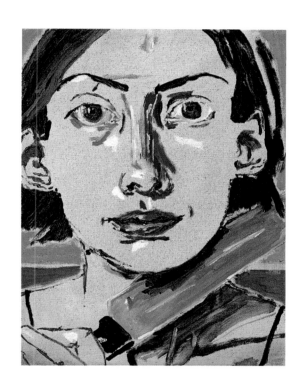

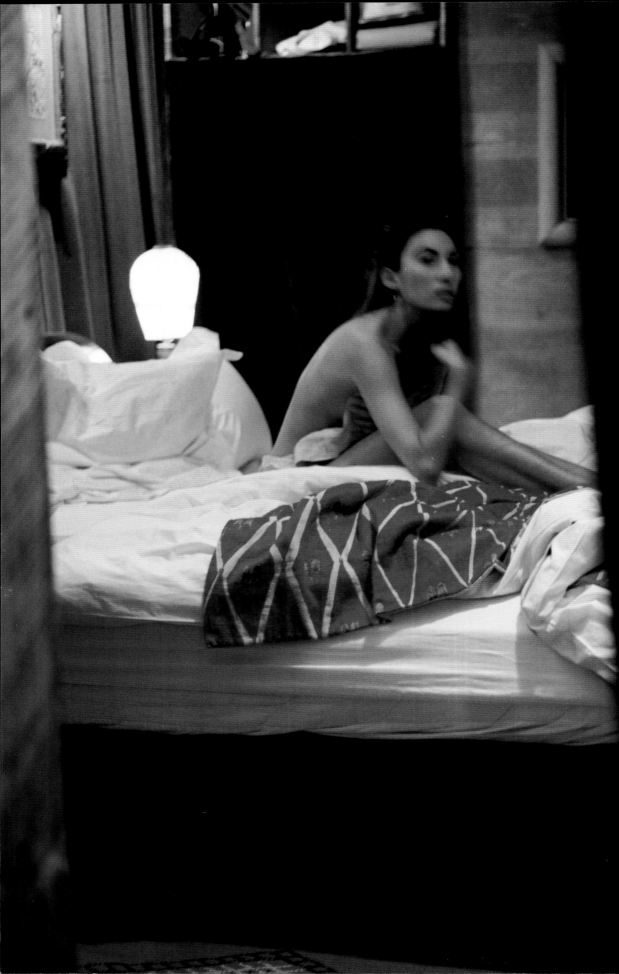

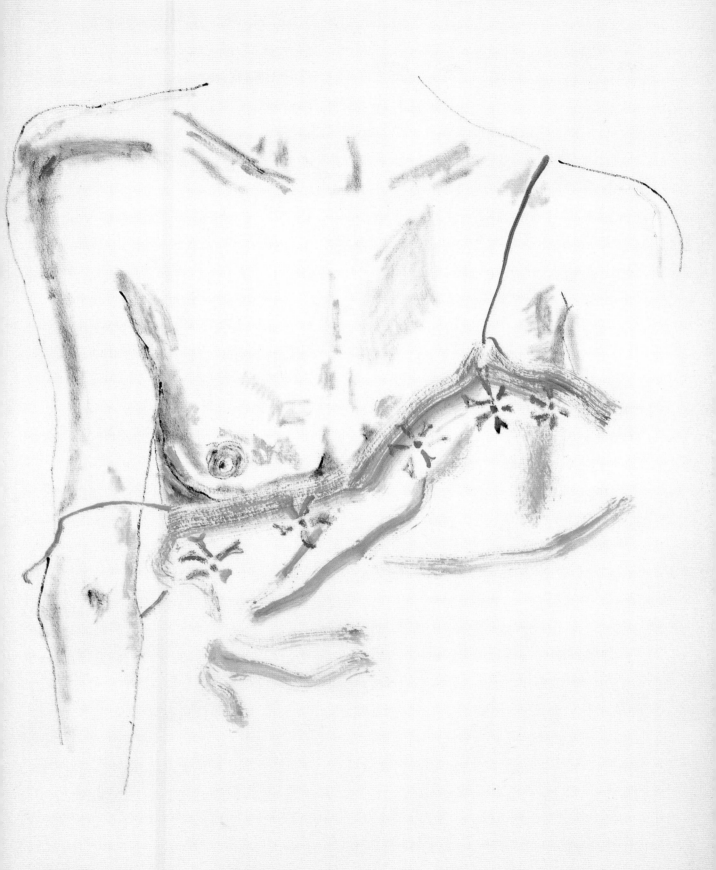

John
Galliano

A self-portrait is something which captures a permanent spirit and a fleeting mood. It is the hardest type of painting to get right and it has nothing to do with the artist and the subject being virtual strangers or knowing each other for years: it is about the chemistry of a moment.

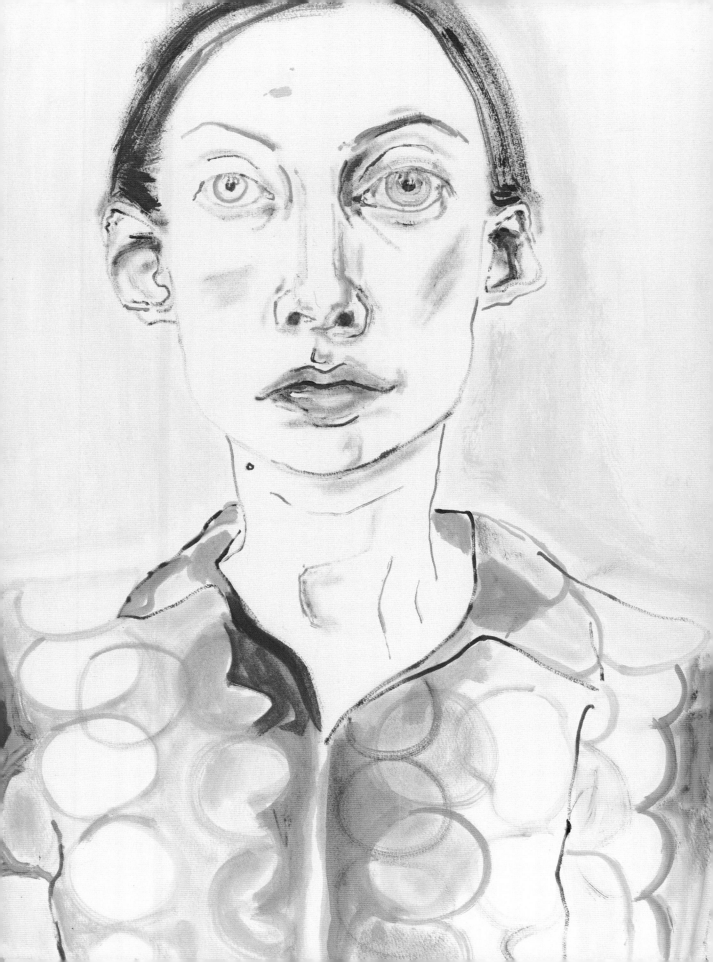

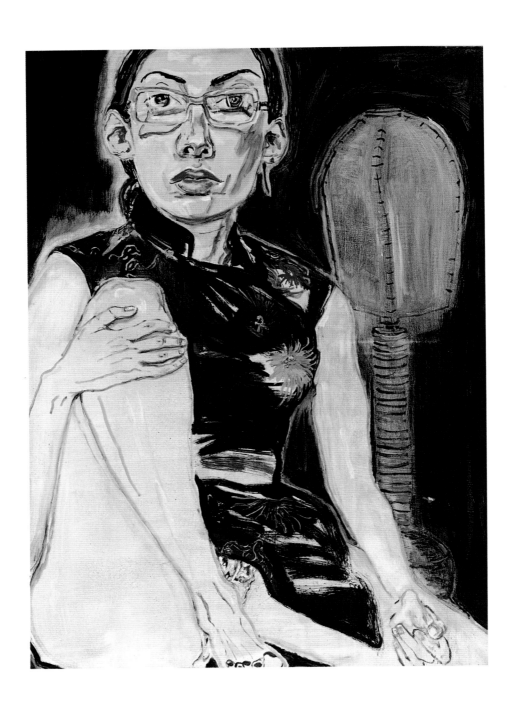

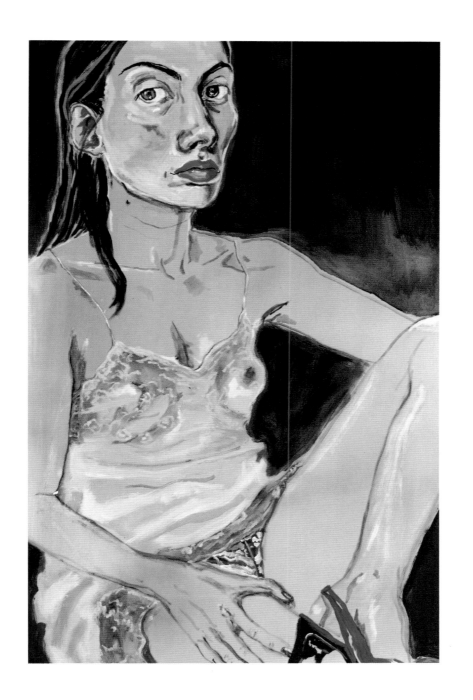

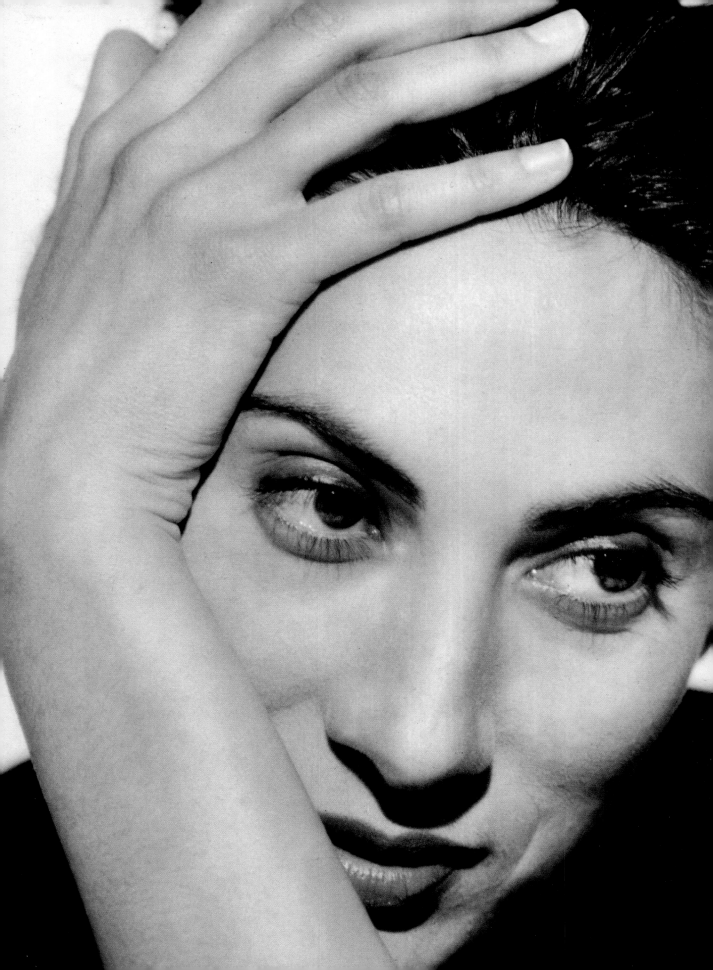

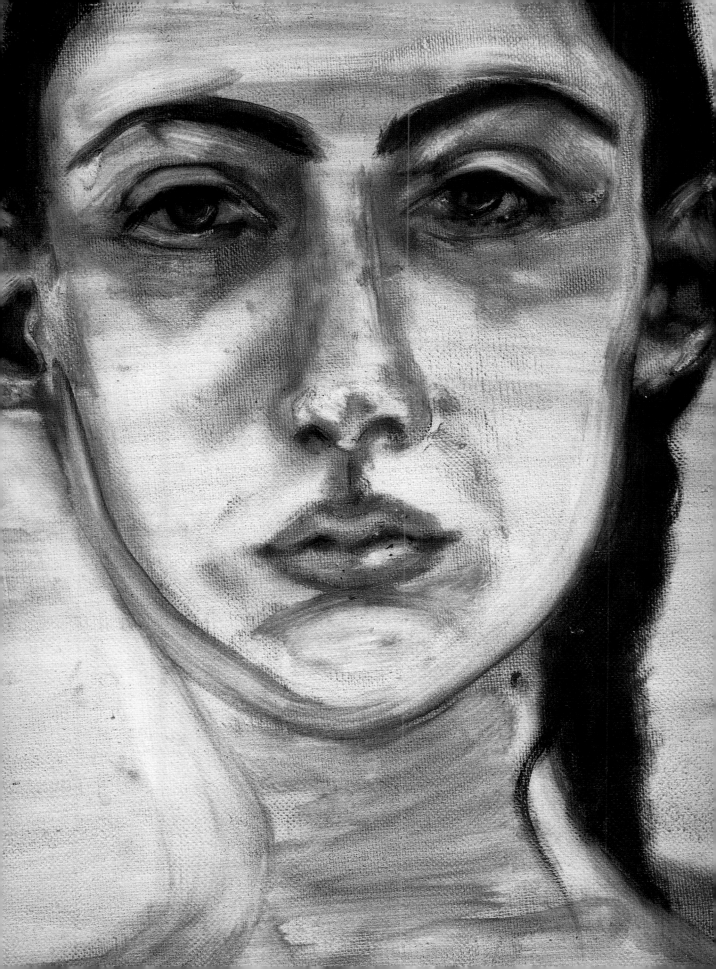

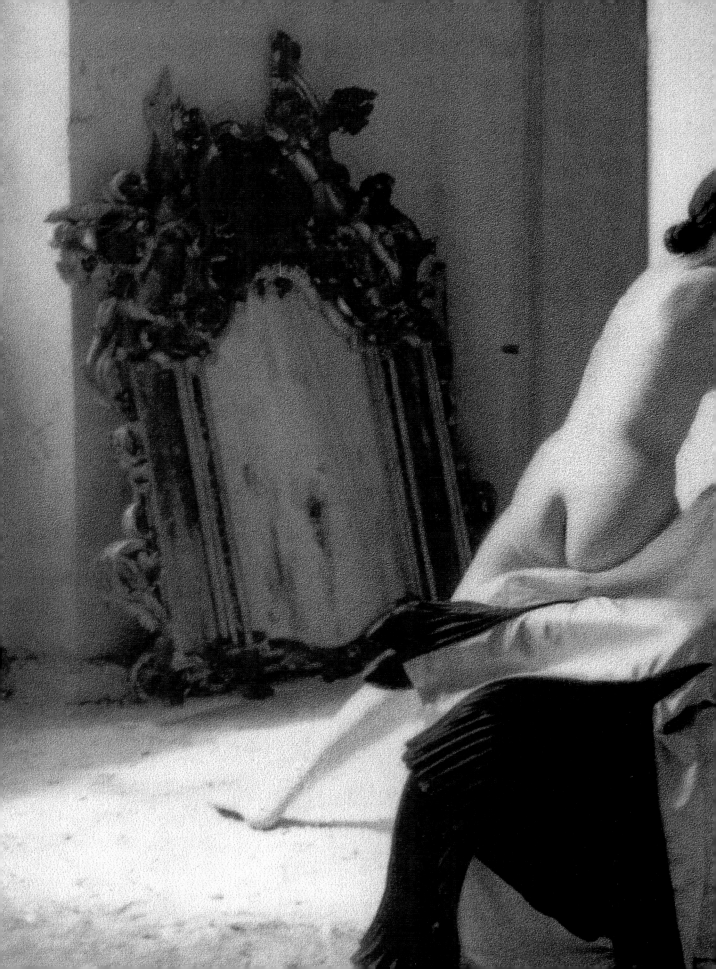

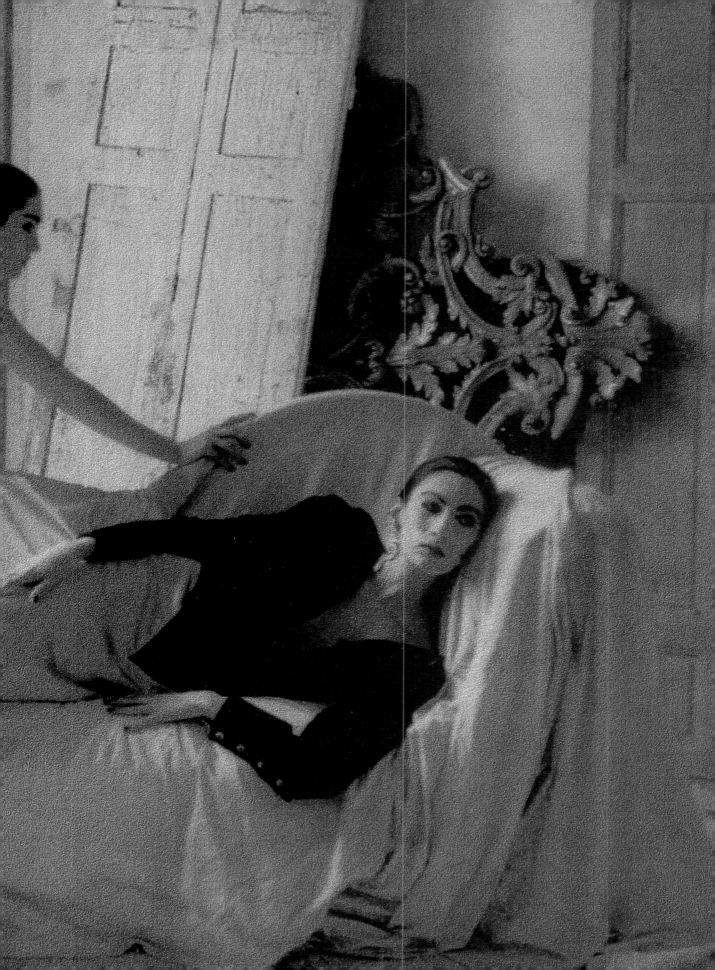

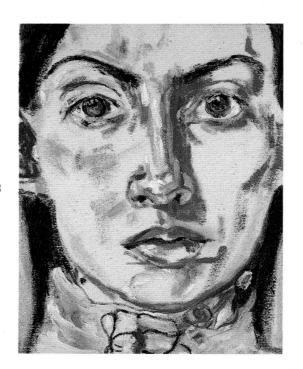
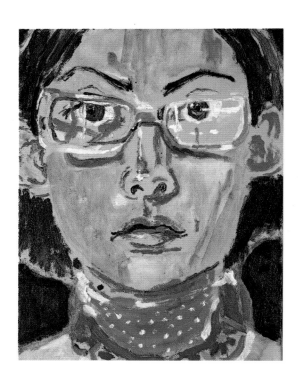

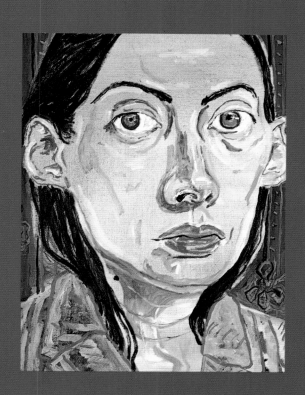
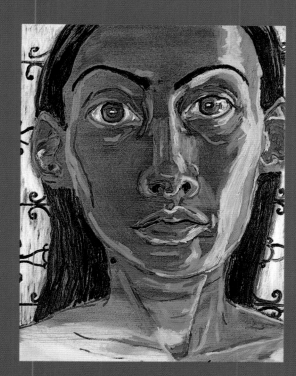

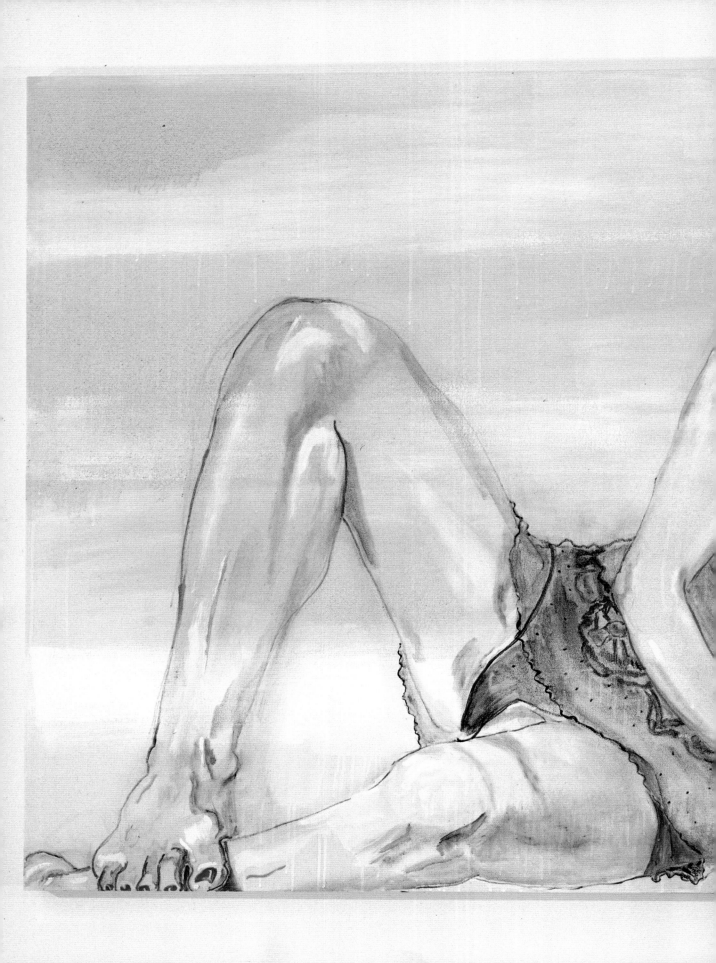

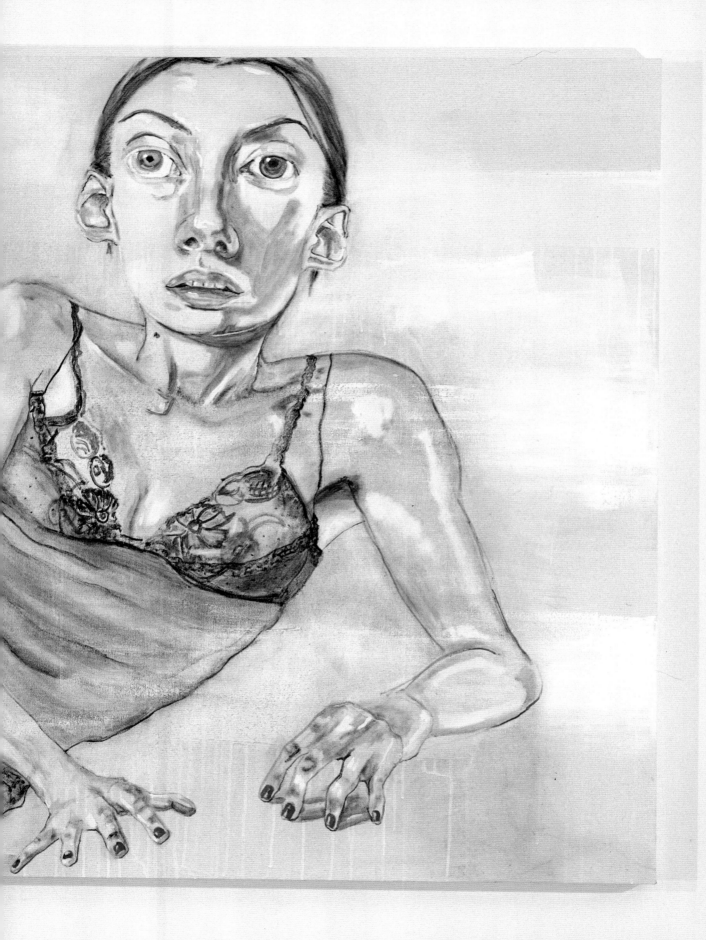

Bernardo
Bertolucci

These self-portraits have a name that starts with a breath, "Anh,"
and ends with the echo of a little zen bell, "Duong." It is a sound, a color,
a sign and the essential element of the faces that she paints,
exploring herself to find out what is hiding behind the mirror. Days, years and loves go by,
but through her transformations as a woman and as an artist, Anh always encounters the
mysterious and unchanging *chagrin* of her beauty.

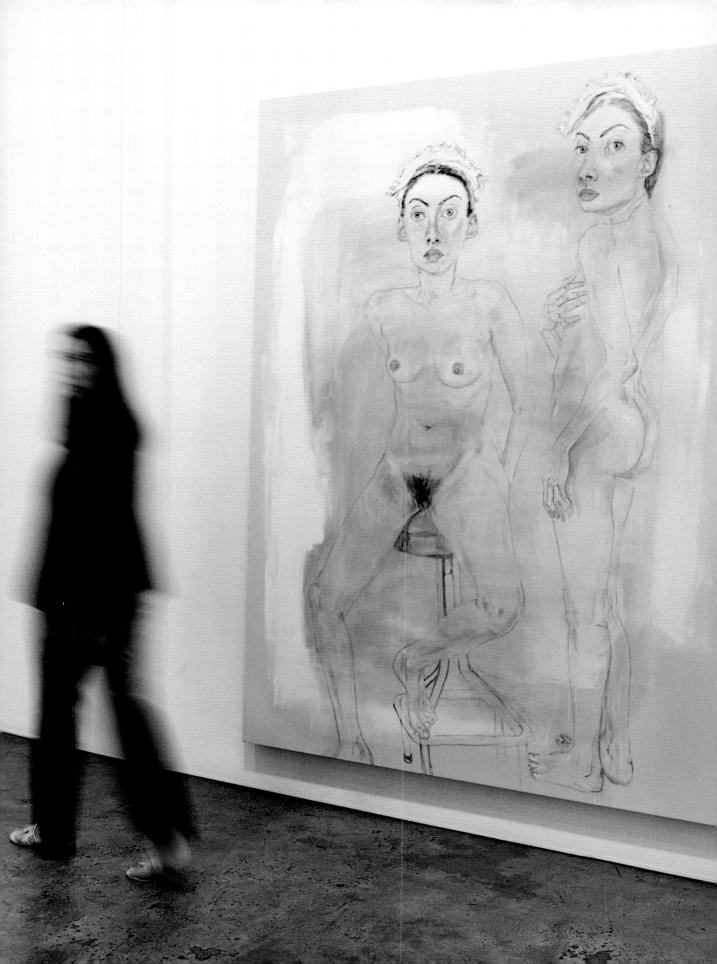

CREDITS

CREDITS

acknowledgments

The author wants to express her deepest gratitude to
the following people who have made this book possible:

Prosper and Martine Assouline,
Dorothée Walliser,
Richard Christiansen,
Peter McGough,
Marc-François Auboire,
Paul Meleschnig,
Jérôme and Emmanuelle de Noirmont,
Vincent Boucheron,
Tony Shafrazi,
Monique Pillard,
Douglas Asch,
Bruce and Regena Thomashauer,
Esther and Loi Duong.

The publisher would like to sincerely thank all the
photographers whose pictures are reproduced in this book:

Mark Abrahams,
Lorenzo Agius,
Michel Comte,
Mai Duong,
Oberto Gili,
Timothy Greenfield-Sanders,
François Halard,
Peter Lindbergh,
Roxanne Lowit,
Peter McGough,
Patrick McMullan,
Steven Meisel,
David Seidner's Estate,
Peter Stanglmayr,
Mario Testino,
Deborah Turbeville,
Javier Vallhonrat.

Our thanks also to Jessica Marx at Art + Commerce, Candice Marks at Art Partner,
Michele Filomeno, and to all the contributors to this book.